EDWARD HOPPER

AN AMERICAN MASTER

ITA G. BERKOW

NEW LINE BOOKS

Fax: (888) 719-7723
e-mail: info@newlinebooks.com

Printed and bound in Singapore

ISBN 1-59764-086-7

Visit us on the web!
www.newlinebooks.com

Author: Ita G. Berkow

Publisher: Robert M. Tod
Book Designer: Mark Weinberg
Production Coordinator: Heather Weigel
Project Editor: Edward Douglas
Editor: Linda Greer
Picture Researcher: Ede Rothaus
Typesetting: Command-O, NYC

SELECTED BIBLIOGRAPHY

Barr, Alfred H., Jr. *Edward Hopper: Retrospective Exhibition. New York*: The Museum of Modern Art, 1933.

du Bois, Guy Pene. "The American Paintings of Edward Hopper." *Creative Art*, 8 (March 1931), 187-91.

Goodrich. Lloyd. *Edward Hopper: Exhibition and Catalogue*. New York: Whitney Museum of American Art, 1964.

Goodrich, Lloyd. *Edward Hopper*. New York: Harry N. Abrams, 1971.

Hobbs, Robert. *Edward Hopper*. New York: Harry N. Abrams, Inc., Publishers in association with the National Museum of American Art, Smithsonian Institution, 1987.

Kuh, Katherine. *The Artist's Voice: Talks with Seventeen Artists*. New York: Harper and Row. 1962.

Levin, Gail. *Edward Hopper as Illustrator*. New York: W. W. Norton & Company in association with the Whitney Museum of American Art, 1979.

Levin, Gail. "Edward Hopper's 'Office at Night'." *Arts Magazine*, 53 (June 1979), pp. 114-21.

Levin, Gail. *Edward Hopper: The Art and Artist*. New York: W. W. Norton & Company in association with the Whitney Museum of American Art, 1980.

O'Doherty, Brian. "Portrait: Edward Hopper," *Art in America*, 52 (December 1964), pp. 68-88.

Tyler, Parker. "Edward Hopper: Alienation by Light." *Magazine of Art*, 41 (December 1948), pp. 290-95.

Todd, Ellen Wiley. "Will (S)he Stoop to Conquer? Preliminaries Toward a Reading of Edward Hopper's Office at Night." Norman Bryson et al., eds. *Visual theory. Painting and Interpretation*. New York: Icon Editions, 1991.

CONTENTS

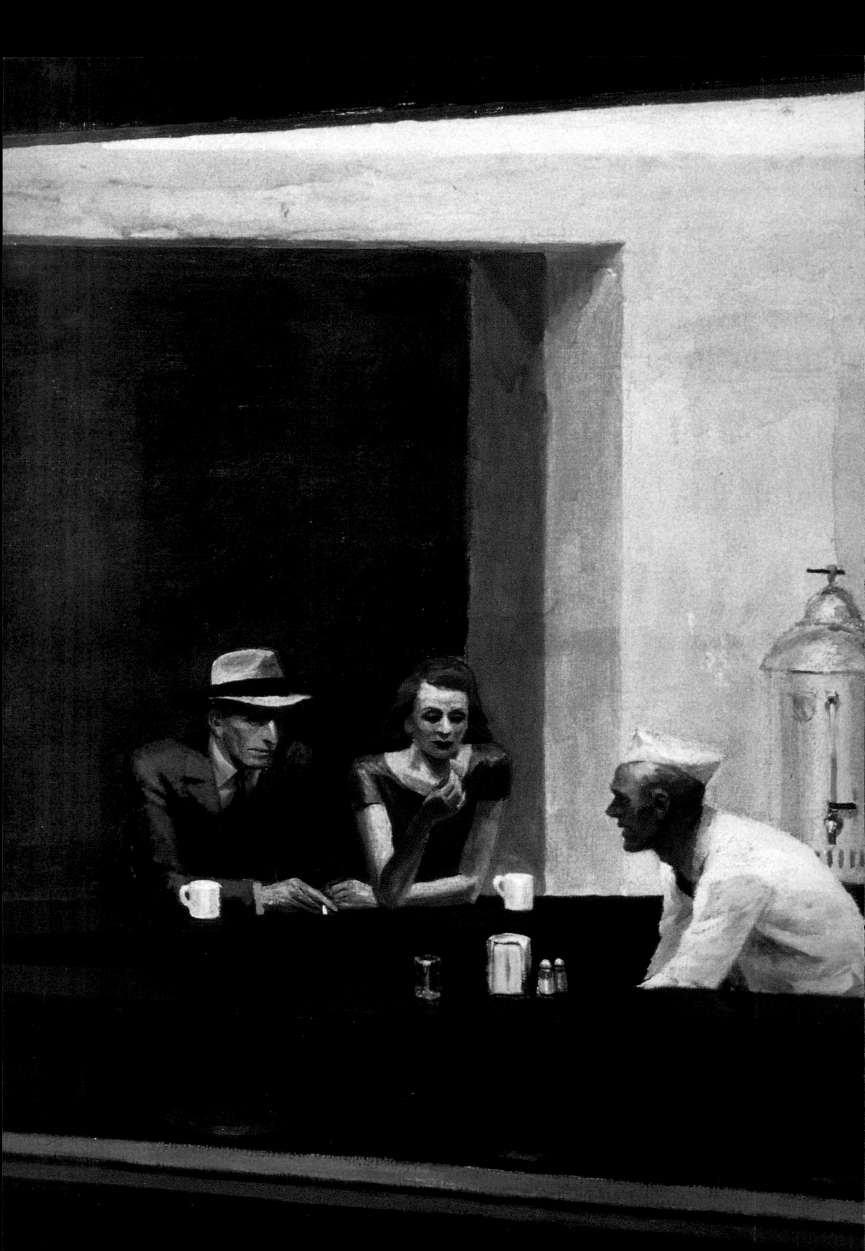

INTRODUCTION

One does not need to be an aficionado of American Art to be familiar with Edward Hopper. Similar to the works of the European impressionists, Hopper's paintings are some of the most well-liked American paintings of the twentieth century. Indeed, his images of city life have garnered such popularity that many have become icons of American pop culture. For example, *Nighthawks* (1942), an image of a diner at night, has been used repeatedly for commercial purposes. The best-selling contemporary poster *Boulevard of Broken Dreams* is an exact replica of *Nighthawks* except for one alteration: the four anonymous figures in the diner have been replaced by Marilyn Monroe, Humphrey Bogart, James Dean, and Elvis Presley. A more recent appropriation of *Nighthawks* can be found on the promotional mugs for Starbucks coffee company. In a clever marketing move, Starbucks replaced the lettering on the diner's storefront sign, which originally said "Phillies," with the words "Starbucks Coffee."

Hopper's art may have influenced film images as well. Similarities have been noted between Hopper's art and the *film noir* style, and both film and art critics are still debating whether Hopper's art was influenced by or was an influence for *film noir*. Most likely, it was a little bit of both. Hopper's work, however, plainly influenced the famous director Alfred Hitchcock. In Hitchcock's thriller *Psycho*, released in 1960, the house in which the killer, Norman Bates, resides is remarkably similar to the house in Hopper's *House by Railroad*, which was painted in 1925. Furthermore, Hitchcock was known to be a great fan of Hopper's art.

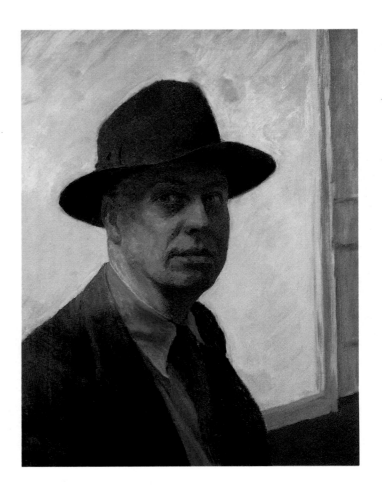

Nighthawks
detail; 1942; oil on canvas; The Art Institute of Chicago
In Hopper's ledger book, the man holding the cigarette
is referred to as a nighthawk, explaining the origin
of the painting's title. In a preliminary sketch for the
piece, the man and his female companion are engaged in
conversation. However, in the final work there is no com-
munication between them and both stare into the distance.

Self-Portrait
1925-30, oil on canvas; 25 1/16 x 20 3/8 in. (64 x 52 cm).
Collection of Whitney Museum of American Art, New York.
Success for Hopper came late in life. When critical recognition
finally arrived, Hopper was well into his forties. Of the many self-
portraits he painted, this one seems to characterize the artist's un-
sureness of his newfound success. Even late in life, after becoming
an established icon in American art, the artist feared bad reviews.

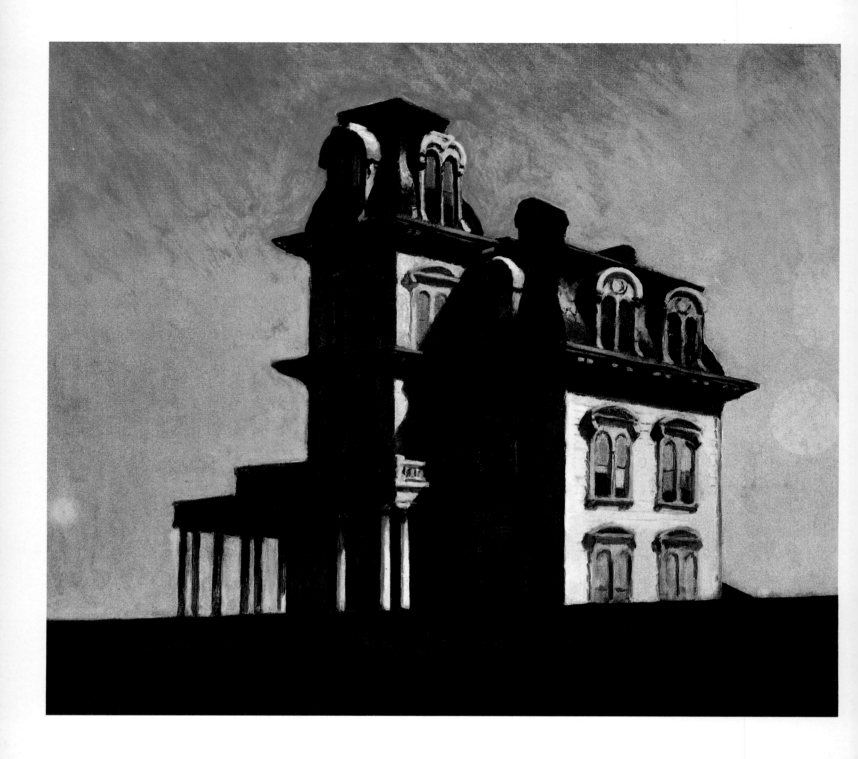

House by Railroad

1925, oil on canvas;
24 x 29 in. (61 x 74 cm).
The Museum of Modern Art, New York.
The growth of cities and railroads
during Hopper's lifetime hastened
the decline and desertion of many
of America's small towns. In this
work Hopper portrays the last
vestige of a bygone era through
his representation of a Victorian
house beside a railroad track.

Unfortunately, Hopper has rarely been credited when his images have been appropriated for commercial purposes. Nonetheless, the wide use of Hopper's art commercially has, in some ways, allowed for the complete immersion of his art into today's mainstream culture. Consequently, one does not need to know who Edward Hopper was to be familiar with his art.

Despite the pop-culture appeal of his images, Hopper himself had very little interest in adopting the latest style or following the latest trend. He was a man of routine who preferred the simple things in life. His physical description matched his persona. In 1964, John Canady, the art critic for the *New York Times*, described Hopper as follows: "A rangy, big-boned man whose appearance suggests that he might have been a member of his college crew around the year 1900."

Despite his success, Hopper's lifestyle changed very little throughout his adult life. He always maintained his primary residence at 3 Washington Square North in New York's Greenwich Village. From the 1930s onward, Hopper and his wife Jo divided the year between Washington Square and their second home in South Truro, Massachusetts. Moreover, the Hoppers always shopped in thrift stores and continued to purchase their clothes at Woolworth's and Sears.

Hopper displayed a similar lack of panache in his interaction with the art world. He was quite shy and incapable of mixing with the "right" dealers and critics. Nonetheless, during his own lifetime, Hopper witnessed two major retrospective exhibitions of his art and was the subject of a *Time* magazine cover story. Accordingly, one must wonder what accounts for Hopper's success as an artist during the first half of the twentieth century, let alone the wide appeal of his images to contemporary viewers.

Although Hopper may have had a rather staid lifestyle, artistically he followed his own instincts and inner visions, combining elements of the Ashcan and Impressionist schools to paint his own unique perspective of America. Hopper's art charts the growth of the cities and technological advances that occurred both in America's cities and its countryside from the 1920s through the 1960s. Hopper, however, chose to picture these changes by painting what was considered, during the early twentieth century, rather unusual subject matter, such as gas stations, hotel lobbies, night scenes, train tracks, lighthouses, offices, and train cars. Moreover, he liked his paintings to explore the psychological effects these subjects had on the people within his works. While Hopper's paintings of people are not narrative per se, his works do require interpretation. They often seem to catch the moment just after something has occurred among the people in the painting; for example, the elderly couple in *Hotel Lobby* (1943) seems to have just ceased bickering.

More than any other painter of the period, Hopper was able to capture the look and feel of American life. In an article for *The Arts Magazine* in 1927, Lloyd Goodrich, Hopper's ardent supporter and biographer, wrote, "It is hard to think of another painter who is getting more of the quality of America in his canvases than Edward Hopper." This ability clearly accounts for much of Hopper's success, yet it does not account for it all.

The appeal of Hopper's images to contemporary viewers as well as their adoption by pop culture must also be attributed to the themes of Hopper's paintings. During his lifetime, Hopper witnessed the shift of the American populace from the country to the city and the modernization of American transportation—changes which theoretically should have facilitated the bringing of people together. Nonetheless, Hopper saw these changes as exacerbating the isolation and alienation of the individual and repeatedly used his art to communicate this idea. The popularity of Hopper's art with contemporary viewers may stem from the universality of this message. Ironically, Americans today are experiencing a communications explosion which should serve to draw the whole world closer together through such mechanisms as the global internet. Yet, for many individuals, this new technology has resulted in an increasingly isolated, dehumanized existence in which faxes and e-mail have replaced human interaction.

Following page:
Manhattan Bridge Loop
detail; 1928; oil on canvas;
Addison Gallery of American Art, Phillips Academy, Andover, Massachusetts.
The massive architecture and concrete pavement of the bridge seems to engulf the walking figure. Hopper meant to capture the vast horizontal expanse of this structure and in doing so he also conveyed the dehumanization of city life. The bleak nature of this theme is strengthened by the drab colors of the neighboring buildings, the tonal flatness of the blue-gray sky, and the waning late-afternoon sunlight.

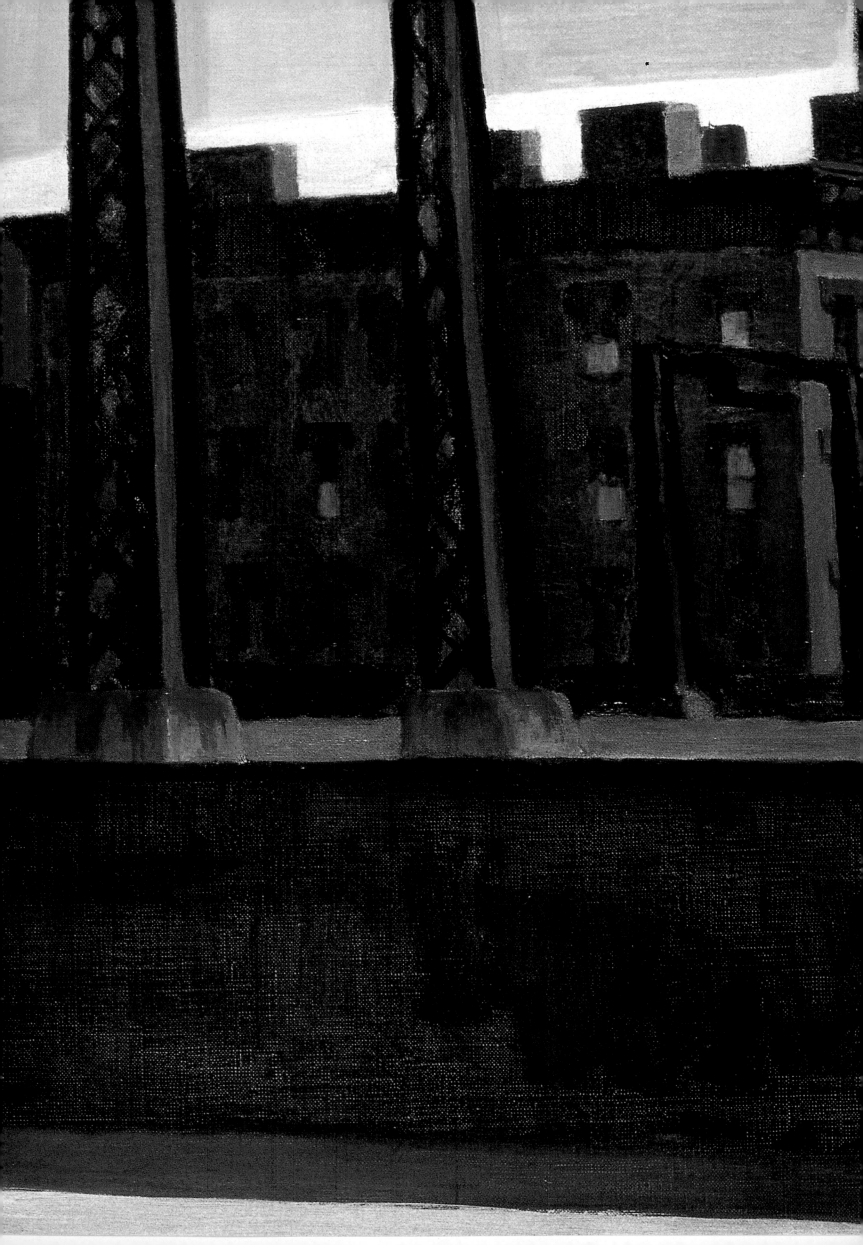

mounted his first one-man show in 1920. Over the years the Whitney has organized a number of similar exhibitions, including its most recent in 1995, "Edward Hopper and the American Imagination."

Methodology

With the exception of the first chapter, which describes Hopper's early experiences and influences, the remaining chapters of this book are divided thematically. In an approach similar to Levin's in *Edward Hopper: The Art and Artist,* Hopper's art is discussed in terms of the central themes that dominate his mature style. Nonetheless, throughout the book, a loose chronological order is followed so that the reader

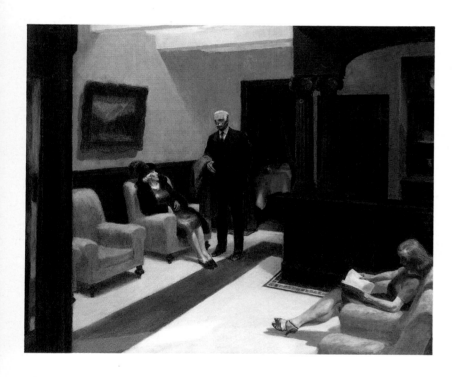

moves from the beginning to the end of Hopper's life in an orderly fashion.

Chapter I introduces the reader to Hopper's early development as an artist. His student years in both New York and Paris are discussed at length, including his early interest in impressionism and his involvement with the Ashcan School. Hopper's mature style is the focus of Chapter II. Beginning with his rise to fame in the early 1920s, this section focuses on the subjects Hopper liked to paint in both New York and the rural countryside of New England. Alienation, a theme commonly portrayed in Hopper's art, is fully introduced in this chapter.

Chapter III discusses Hopper's interest in travel. This chapter was inspired by Robert Hobbs, who discussed the effects of the automobile on the American landscape at length in his book. Hopper's interest in the subject of travel also extended to his depictions of gas stations, the interiors of train cars, highways, and hotel rooms and lobbies, as well as to the psychology of the traveler.

Hopper's late works and the reemergence of sunlight in them is the focus of Chapter IV, the final chapter in this book. In his later years Hopper tended to allow sunlight to dominate his canvases. The reason for his renewed interest in light and the spiritual significance it may have held for Hopper is a central question of this section. The chapter ends with an examination of Hopper's final works and farewell painting, *The Two Comedians* (1965).

Hotel Lobby
1943, oil on canvas; 32 1/2 x 40 3/4 in. (83 x 103 cm).
Indianapolis Museum of Art, William Ray Adams Memorial Collection.
The frozen stillness and lack of interaction in Hopper's paintings were clearly intentional. In contrast to the finished painting, the preliminary drawings for *Hotel Lobby* show the elderly couple engaged in conversation and a young man seated in the place of the girl reading. Hopper used real-life observations, watching people in hotel lobbies for later use as models or as ideas to be composed and re-formatted in his studio.

Early Sunday Morning
detail; 1930; oil on canvas;
Collection of Whitney Museum of American Art, New York.
In "a literal translation of Seventh Avenue," Hopper presents the exterior of a barber shop, one of the small businesses that lined the avenue. Himself a small-town boy, Hopper favored the remnants of town life in New York, and his paintings are lasting impressions of the time preceding their ultimate demise.

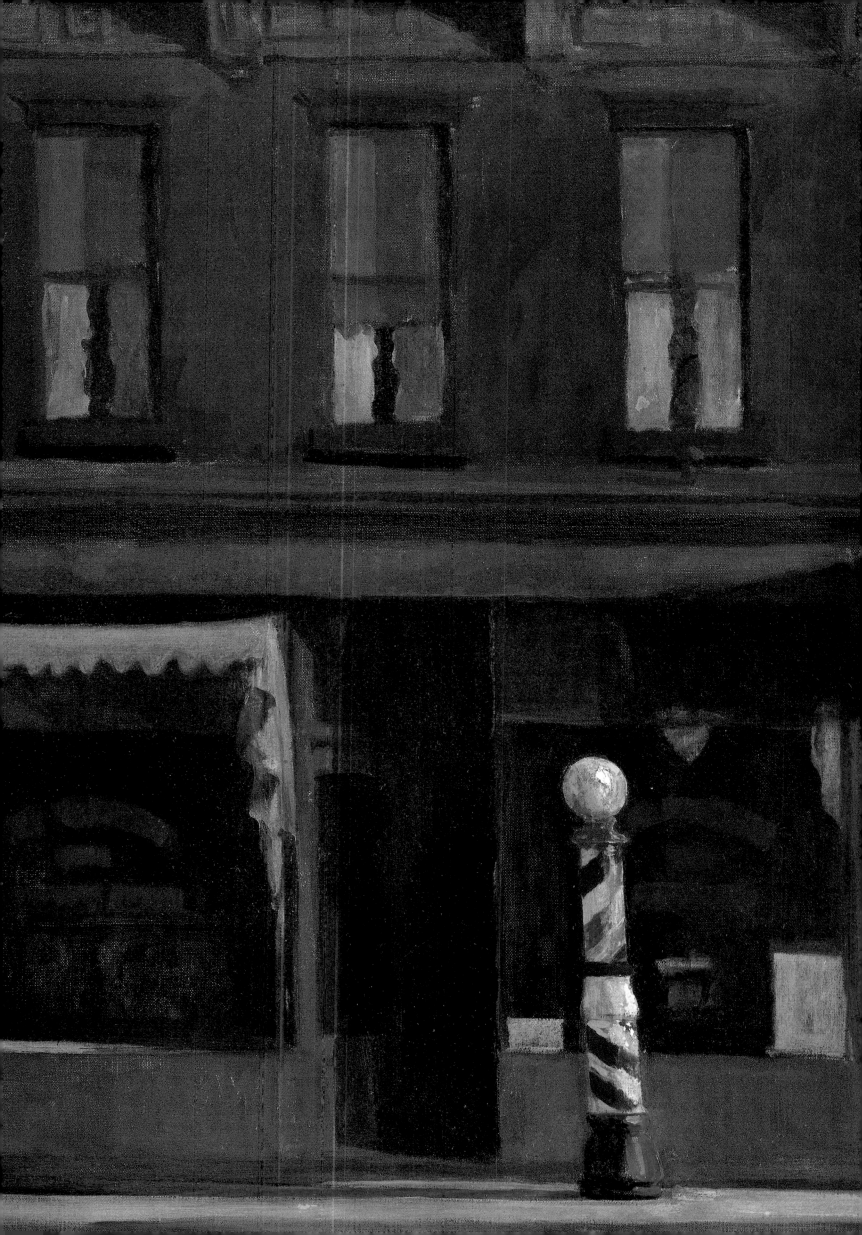

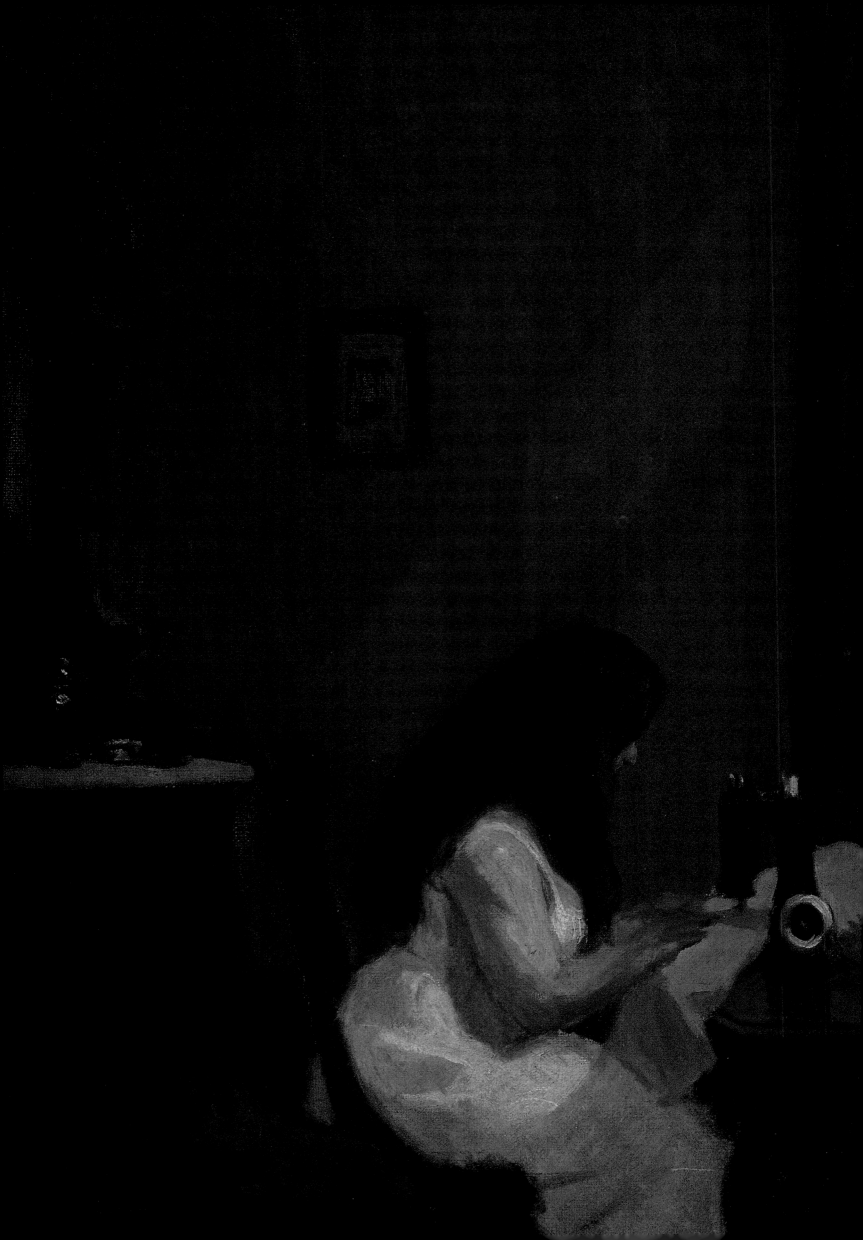

EARLY DEVELOPMENT: NEW YORK AND PARIS

*A*ccording to Hopper, much of his artistic identity arose from his origins. Indeed, as the artist explained after achieving recognition, "in every artist's development, the germ of the later work is always found in the earlier. The nucleus around which the artist's intellect builds himself, the central ego, personality, or whatever it may be called, and this changes little from birth to death. What he once was, he always is, with slight modifications."

Edward Hopper was born in the small seafaring town of Nyack, New York on July 22, 1882. Hopper's parents, Garrett Henry Hopper and Elizabeth Griffiths Smith, were of English and Dutch descent. The family was middle class; Hopper's father was a local businessman who owned a dry-goods store in Nyack. Both Hopper and his sister Marion were exposed to the arts during childhood by their mother, who encouraged them to draw. Hopper was brought up attending a local private school and later Nyack High School.

Hopper's love of the sea, reflected in his later works, stemmed from his childhood. Hopper passed his childhood summer days at the shipyards of his hometown. When he was fifteen, his father gave him materials to build a catboat. Yet the boat never sailed very well and may have ended Hopper's dreams of pursuing a career as a naval architect.

Student Days

After his high school graduation in 1899, Hopper wanted to pursue a career as a fine artist. His parents, however, had other aspirations for their son and, under their advisement, he enrolled at the Correspondence School of Illustrating in New York City.

Girl at Sewing Machine

c.1921, oil on canvas; 19 x 18 in. (48 x 46 cm).
Museo Thyssen-Bornemisza, Madrid 1995.
The subject of this painting, a woman sewing by an open window, is a motif common
to the Ashcan School. Here Hopper transforms sewing, a subject often used by artists to
connote domestic harmony, into a study of light and the contemplation of the woman's
lone activity. Hopper later explored this same theme in his etching *East Side Interior* (1922).

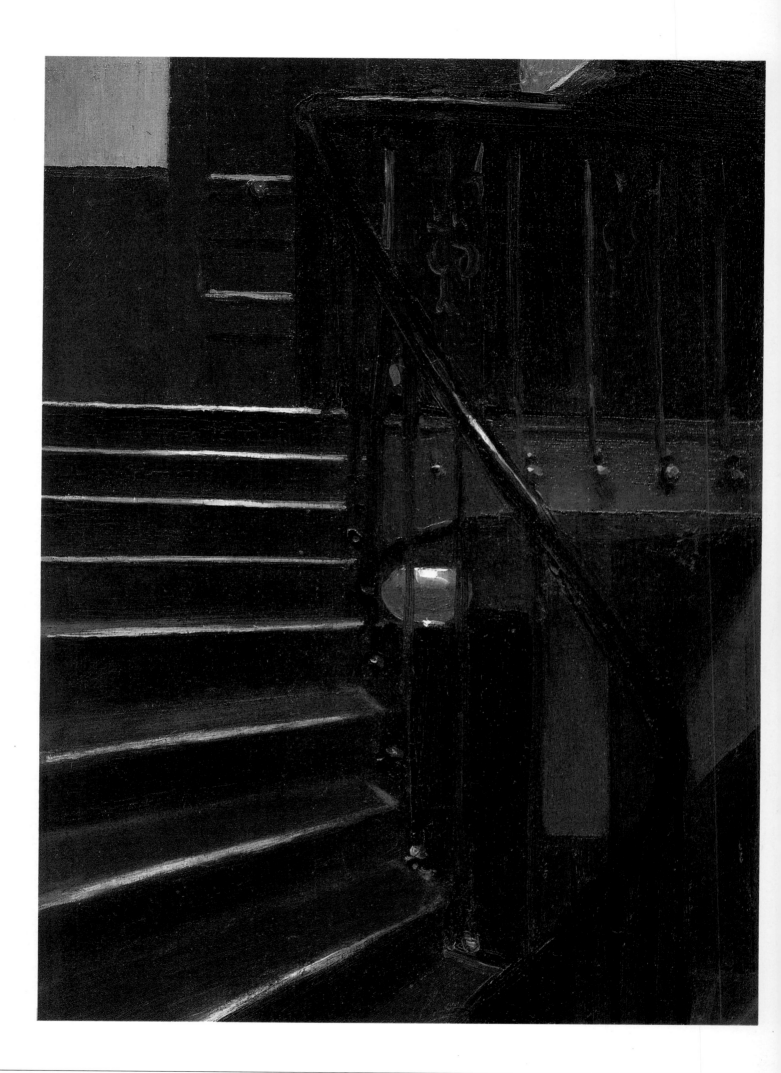

Disappointed with illustration school, Hopper transferred the following year to the New York School of Art, commonly known as the Chase School. For the next six years he studied there principally under William Merrit Chase, Kenneth Hayes Miller, and Robert Henri.

Chase himself painted in an impressionist style. The New York art scene during this period, however, was changing rapidly. In the early decades of the century, a radical group of American artists departed from the soft, genteel qualities of impressionism. This group of artists was commonly known as the Ashcan School. Although they retained much of the impressionist style, they sought to paint the harsher, more urban qualities of contemporary life. Their subject was the city, and they did not hesitate to portray its seedy side. Indeed, the name Ashcan School was coined as a derogatory comment on the bleak nature of the group's subject matter.

Hopper's teacher Robert Henri was one of the major proponents of this style. Moreover, Hopper's student works reveal that Henri, as opposed to Chase, was Hopper's primary influence at the Chase School. Though examples of Hopper's student works are limited, those that do exist evidence the dark palette and heavy brushstrokes favored by the Ashcan School. Additionally, Hopper's early exposure to Henri may have served as the catalyst for his future focus on depicting the harshness of city life.

European Tour

From the eighteenth century through the early twentieth century, the goal of every American art student seemed to be to visit Europe. Recalling his European travels Hopper once said, "In my day you had to go to Paris. Now you can go to Hoboken; it's just as good."

Between 1906 and 1910 Hopper took several trips to Europe, which included extended stays in Paris. He earned the money for these journeys through illustration, a profession he abhorred but which would support him through his years as a struggling artist.

During his first trip to Paris in 1906, Hopper's parents arranged for him to stay with a French family on the Rive Gauche. Hopper recorded his stay with this family in his *Stairway at 48 Rue de Lille, Paris*. In this charming oil, he depicted the stairway of his hosts' Parisian apartment building.

Upon his arrival, Hopper was immediately captivated by Paris. He enjoyed strolling along the Seine, stopping at cafés, visiting the museums, and absorbing the artistic scenes. In an interview with Brian O'Doherty, Hopper reminisced,

> I could just go a few steps and I'd see the Louvre across the river. From the corners of the Rues du Bac and Lille you could see Sacré Coeur. It hung like a great vision in the air above the city. Who did I meet? Nobody. I'd heard of Gertrude Stein but I don't remember having heard of Picasso at all. I used to go to the cafés at night and sit and watch. I went to the theater a little.

Patrick Henry Bruce, a former classmate of Hopper's from the New York School of Art living in Paris, introduced Hopper to the works of the French impressionists, particularly Sisley, Renoir, and Pissarro. He also saw the works of Manet and Goya at the Louvre. Hopper was

Summer Interior

1909, oil on Canvas; 24 x 29 in. (61 x 74 cm).
Collection of Whitney Museum of American Art, New York.
A young woman seated on the floor in a sunlit interior is an element common in many of Hopper's works. Hopper repeatedly used a female figure seated by a window to convey a range of feelings including loneliness, alienation, and sadness. The style of this early work has its precedents in the Ashcan School.

Stairway at 48 Rue de Lille, Paris.

1906, oil on wood; 13 x 9 1/4 in. (33 x 23 cm).
Collection of Whitney Museum of American Art, New York.
This is a view of the entrance to the house in which Hopper stayed during his first trip to Paris in 1906. His early interest in architectural forms is apparent and the unusual placement of these elements will continue to be a characteristic of his style.

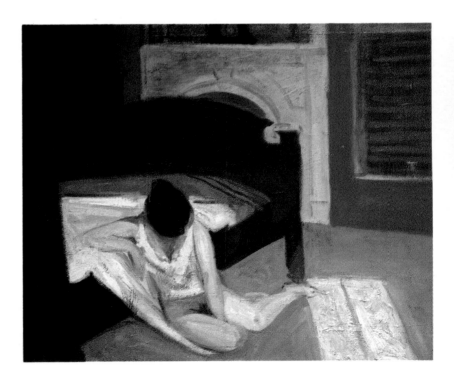

artists of the Ashcan School. In 1913, Hopper entered *Sailing* into the International Exhibition of Modern Art, commonly known as the Armory Show. This work sold for $250. Unfortunately, it would be his first and last sale of a painting, as opposed to illustrations and prints, for over a decade. That same year Hopper moved his studio to 3 Washington Square North. This address would serve as his studio and home for the remainder of his life.

Despite his lack of recognition, Hopper experienced much growth as an artist during the decade following his first sale. He experimented with a melange of artistic styles, and it is not surprising to see both Impressionist and Ashcan techniques in his works of this period.

Nonetheless, the impact on Hopper's art of his trips to Europe extended well into the 1910s. Hopper once said, "It took me ten years to get over Europe." As of 1915, Hopper still felt that his French works were superior to his American ones and preferred to enter

them into exhibitions. The culmination of Hopper's preference for French subject matter is best exemplified by his *Soir Bleu*, a work he submitted to the McDowell Club group show of 1915. Gail Levin has suggested that Hopper was working within the French tradition of the *fête galante*, and that his clown is a modern version of Watteau's *Gilles* (c. 1721). Additionally, Levin has commented that the standing woman in the work is a prostitute approaching prospective clients—an idea Hopper may have borrowed from his attendance at the Carnival of Mi-Carême in 1907. Despite the ambitious nature of the work, critics reviewed it negatively. Instead, they admired Hopper's other submission, *New York Street Corner* (1913).

In response to the negative criticism of *Soir Bleu*, Hopper never again entered the work in an exhibition. Furthermore, his subsequent submissions to the McDowell Club group shows, such as *American Village*, dealt primarily with American subject matter.

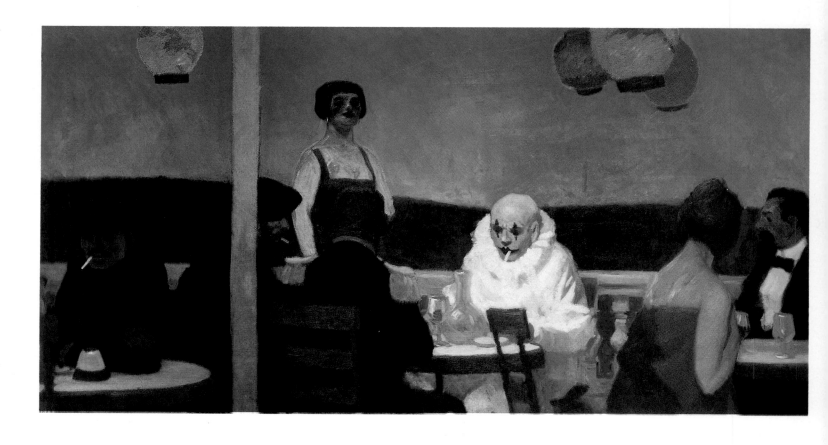

Soir Bleu
1914, oil on canvas; 36 x 72 in. (91 x 183 cm).
Collection of Whitney Museum of American Art, New York.
In the tradition of Watteau's *fête galantes*, this painting reveals Hopper's interest in French subject matter shortly after his travels abroad. When the work was exhibited at the MacDowell Club in 1915 critics unfavorably viewed it as an "ambitious fantasy." It was Hopper's more American-style works that would later attract critical attention.

Le Pont Royal
detail; 1909; oil on canvas;
Collection of Whitney Museum of American Art, New York.
In the manner of the French Impressionists, Hopper painted his Parisian subject of *Le Pont Royal* with strong brushstrokes. The artist conveys the immediacy of the moment through his rendering of light and water.

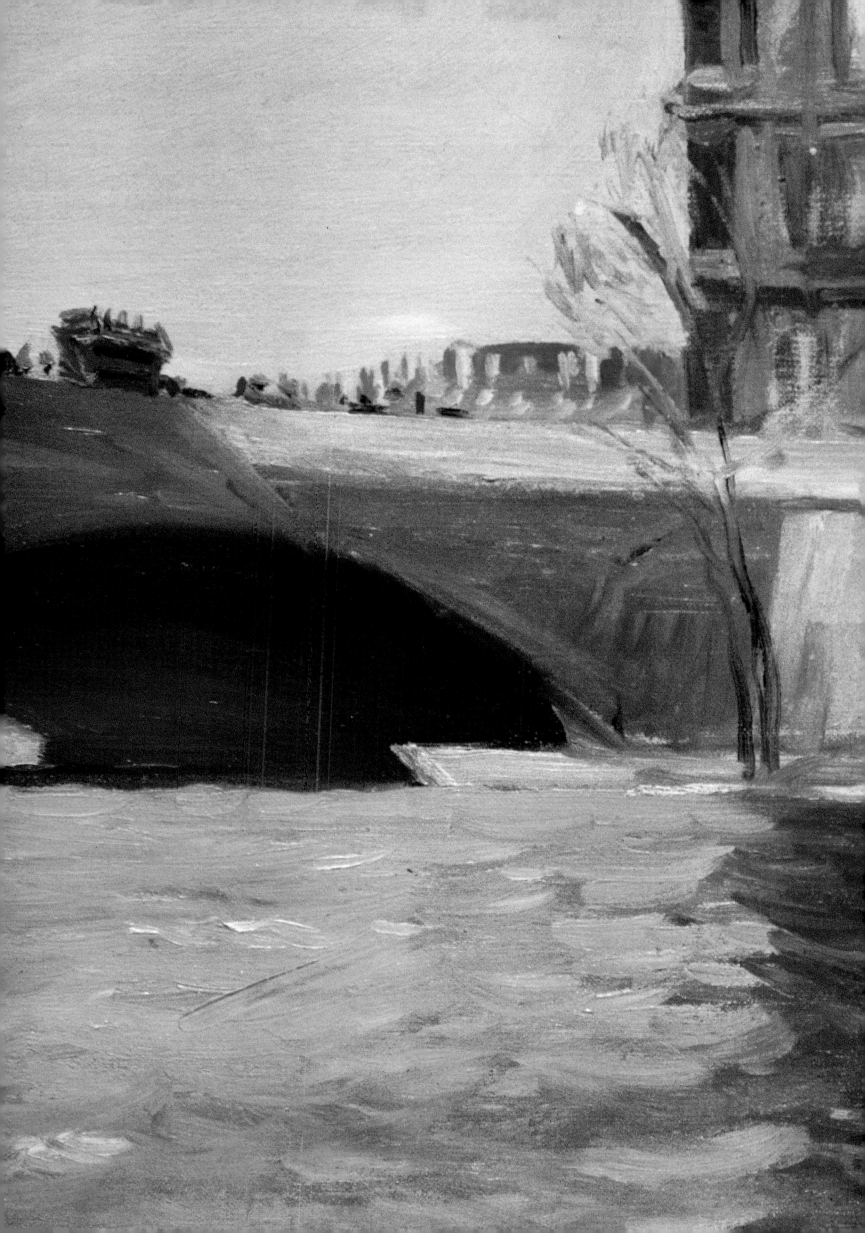

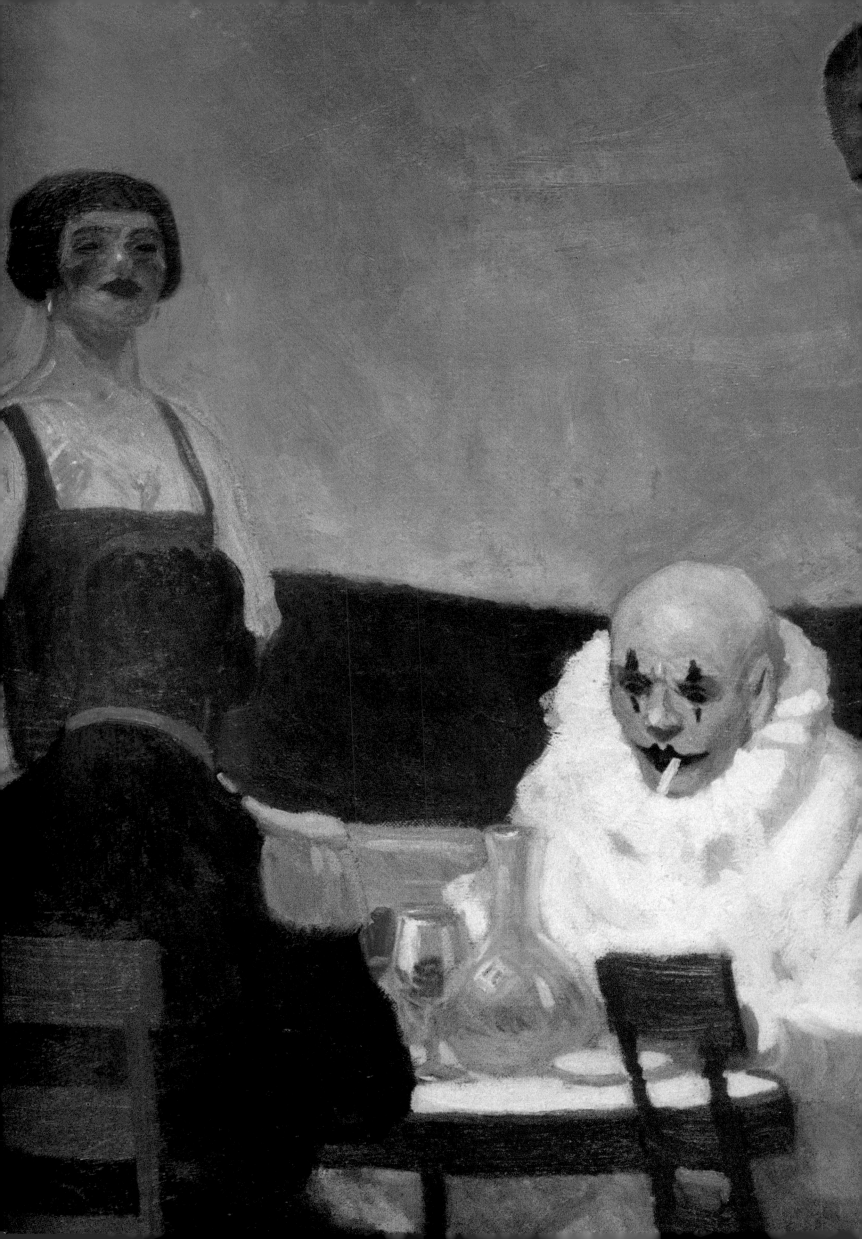

Summers in Maine

During the 1910s Hopper's commercial work flourished. He illustrated regularly for such magazines as *The Farmer's Wife* and *Country Gentleman*. The money he earned as an illustrator enabled him to spend summers in Maine. In 1916, Hopper joined fellow artists Robert Henri, Rockwell Kent, and George Bellows in Monhegan Island, Maine. He was captivated by the rocky coastline of Maine and produced a number of works during the many summers he spent there. Hopper painted outdoors, and his works such as *Blackhead Monhegan* (1916-19) and *Rocky Cliffs by Sea* (1916-19) reveal the rugged, tempestuous qualities of nature.

Moreover, these works contain a temporal quality which Hopper created through his use of brushstrokes and thick impasto. It is interesting to note that virtually all of Hopper's Maine paintings border on abstraction and are yet another example of the artist's experimental nature during this period.

Etching

Although his paintings did not sell during the 1910s, Hopper did begin to experience success as a fine artist during this period through his etchings. In 1915, he was introduced to this medium by his friend Martin Lewis. His prints subsequently sold well, and he began to exhibit them regularly. Hopper's poster *Smash the Hun* (1918), for example, won first prize from the United States Shipping Board poster competition. He also made a number of movie posters during the late teens, as well as a poster for the American Red Cross.

The etchings of the early twenties are perhaps the closest in subject matter to Hopper's mature works, for in these works he concentrated on city life. His etching *Evening Wind* is a precursor to his later works of solitary women by windows. Robert Hobbs has suggested that it is a modern-day Danaë. Hobbs has further suggested that Hopper's etchings of this era may have been inspired by John Sloan's New York City Life etching series.

In *Night Shadows* (1921), Hopper adopted an unusual vantage point, an element characteristic of his mature style, for his etching of a lone figure walking down a deserted street at night. His depiction of the night, with its artificial light, lends an air of mystery to the piece. As in all of Hopper's later works the narrative is left up to the viewer to decipher. Furthermore, alienation, a common theme in Hopper's later paintings, is partially introduced into this early work through the isolation of the walking figure.

By the 1920s Hopper was gravitating towards his mature style. Through his etchings of city life, he was able to forge his own artistic style, apart from those of the Impressionist and Ashcan schools. That is not to say that he did not retain certain aspects of these styles; throughout his lifetime he would always be concerned with depicting sunlight and city life. Hopper's mature style, however, relied on something much more important than the influence of artistic schools. As Hopper himself explained: "The only real influence I've ever had was myself."

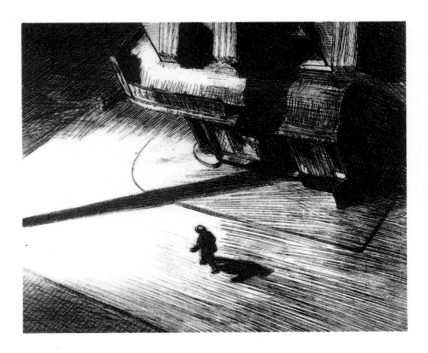

Soir Bleu

detail; 1914; oil on canvas;

Collection of Whitney Museum of American Art, New York.

Of the many characters in this painting, the clown smoking a cigarette is perhaps Hopper's most poignant. Furthermore, the clown's presence lends a theatrical note to the work. Though none of the other seated figures are as vividly portrayed, the sad, downcast aspect of this strikingly-costumed man contrasts strongly to the haughty assurance of the woman standing on the left.

Night Shadows

1921, etching; 7 x 8 3/8 in. (18 x 21).

Collection of Whitney Museum of American Art, New York.

In 1915 Hopper was introduced to the etching medium by his friend Martin Lewis. The resulting etchings were the first of Hopper's works to sell and receive critical acclaim. Here he employs an unusual bird's-eye-view of the subject, a lone figure walking on a deserted sidewalk at night. Hopper's art seems to have been the stimulus for the 1940s cinematic style *film noir*.

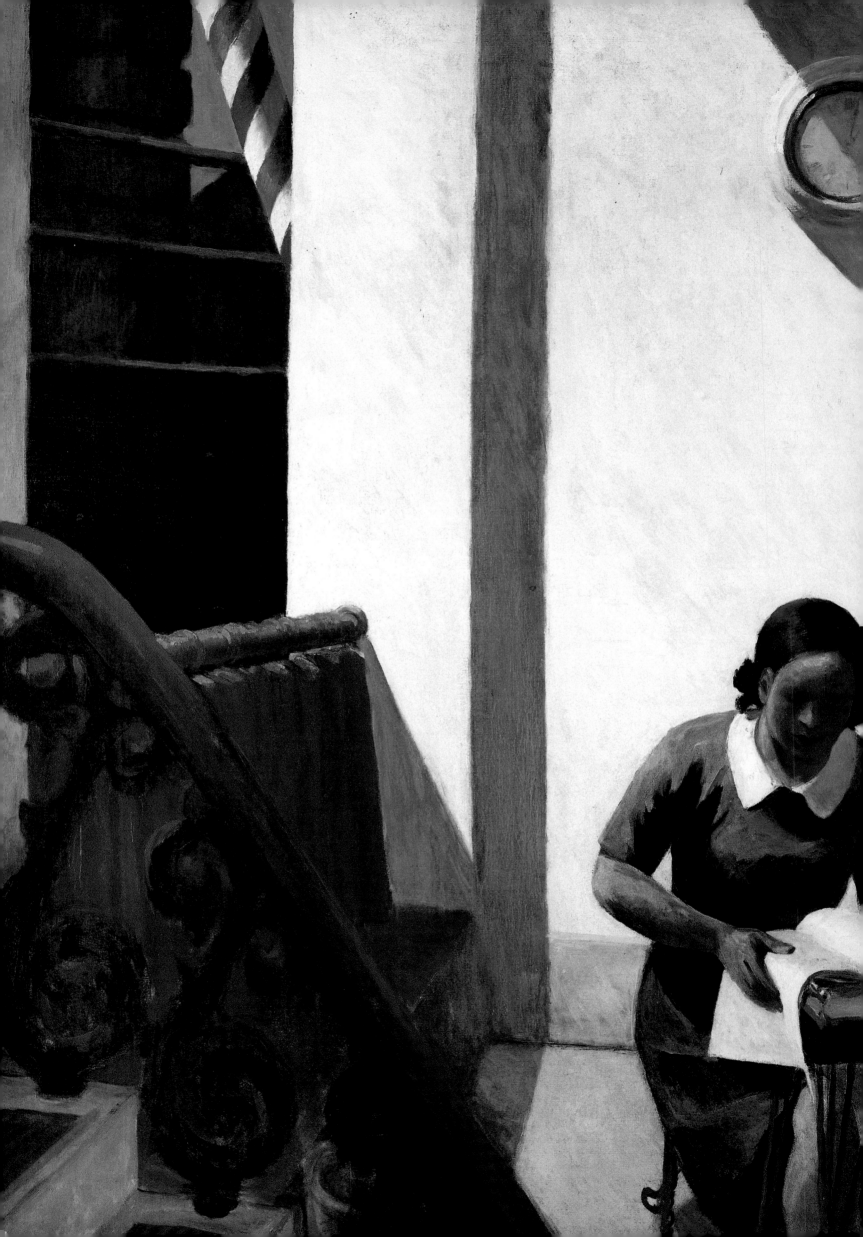

The Barber Shop
1931; oil on canvas;
60 x 78 in. (152 x 198 cm).
Collection of Neuberger
Museum, Purchase College,
State University of New York,
gift of Roy R. Neuberger.
The interior of this barber
shop could well be one
of the storefronts in *Early
Sunday Morning*. Hopper
conveys the quiet solitude
of the place, a theme close
to his heart, through his
depiction of the manicurist.
Free from distraction, she
reads a magazine while
waiting for a customer.

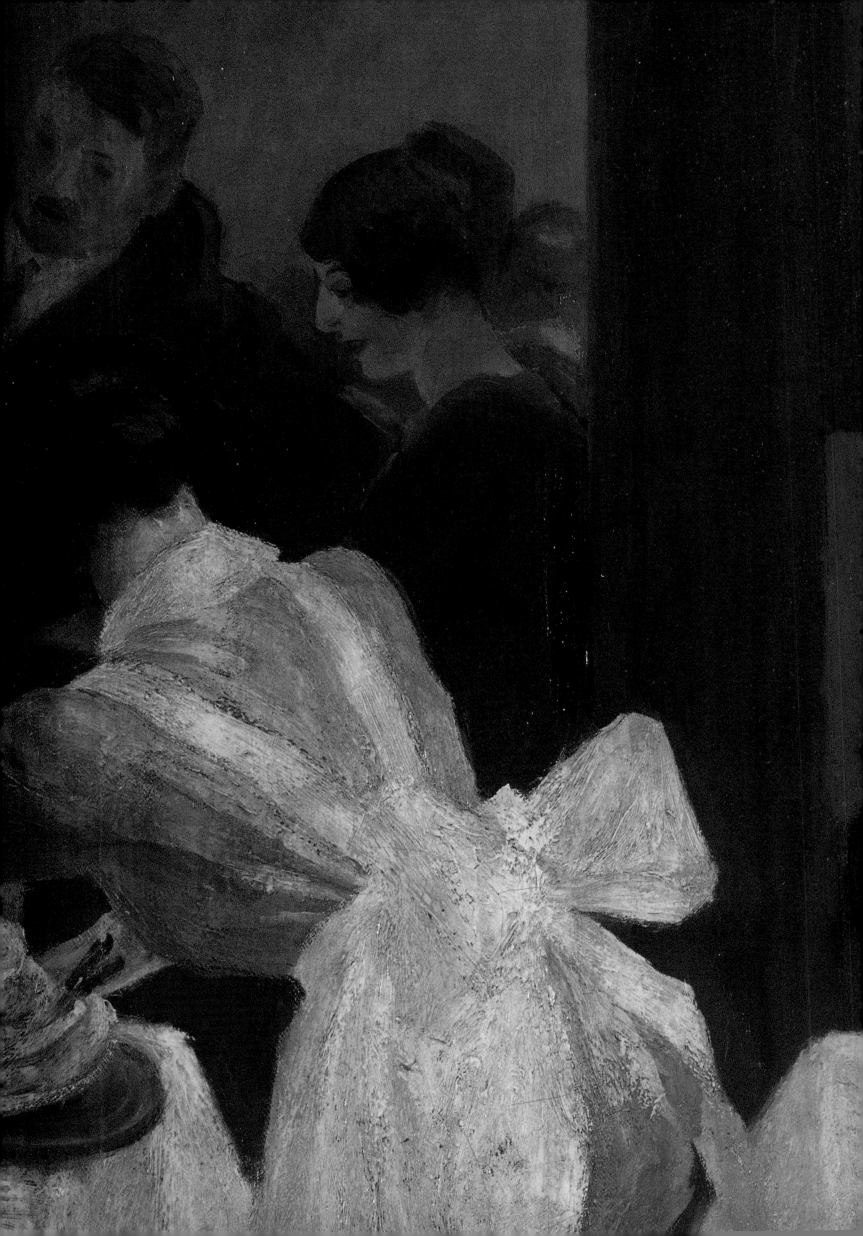

MATURITY: LIFE IN THE CITY AND COUNTRY

During the 1920s and 1930s, Hopper's art increasingly gained recognition. By 1933, he was considered a leading American artist of the period—a position confirmed by his retrospective exhibition at the Museum of Modern Art in that same year.

Hopper's personal life flourished during this period as well. In 1924 he married Josephine Verstille Nivison or, as Hopper fondly called her, Jo. In Jo, he found a soulmate, and for the next forty-three years the Hoppers were inseparable. Moreover, Jo's contribution to the artist's success was profound. She was a formidable woman who promoted her husband's work, managed most of his affairs and also served, possibly due to her own jealousy, as Hopper's only female model after their marriage.

Edward and Jo

Hopper met Jo during their student days at the New York School of Art where both were students of Robert Henri. Henri's portrait of Jo, entitled *The Art Student* (1906), captures the youthfulness that Hopper must have seen upon his first encounter with her. Nonetheless, Hopper and Jo initially viewed each other only as friends. The romance between the two did not begin until years later.

In December of 1922 both Hopper and Jo were included in the same group show, by chance, at the Belmaison Gallery at John Wanamaker's in New York. This show may have helped to spark their romance, as the two spent the following summer together in

Jo Painting
1936, oil on canvas; 18 x 16 in. (46 x 41 cm).
Collection of Whitney Museum of American Art, New York.
Primarily a watercolorist, Jo's art was overshadowed by Hopper's success, and after they married she became his manager and defense against the world. Jo insisted that she be the model for all of Hopper's female figures, and from 1924 on she is the key player in all of his paintings. Though he painted her in many moods and guises, this is a rare portrait of Jo herself.

New York Restaurant
detail; 1922; oil on canvas;
Hackley Picture Fund, Muskegon Museum of Art, Michigan.
The sharp angle of the waitress's body as she leans forward to clear a table, which is largely cropped from our view, successfully captures the bustling activity of a crowded city restaurant at the lunch hour.

and 1930s it took Hopper only a week to complete a painting. From 1940 onward, however, he produced no more than two to four oils per year.

Another interesting aspect of Hopper's mature style is the imaginative fantasies played out in his paintings. The ledger books of his works reveal that he and Jo nicknamed many of the characters in the paintings and created elaborate stories surrounding them. In *Intermission* (1963), he and Jo named the woman in the work Nora. Nora's character is described by the Hoppers as one who "is not the kind to slip feet out of long reasonably high heeled pumps." Hopper further theorized that "Nora is on the way to becoming an 'egghead.'" Hopper's ledger books also reveal that the relationship between himself and Jo was quite crucial to the formation of his style. Jo not only served as Hopper's muse but was also his collaborator in their game of storytelling.

Once developed, Hopper's mature style changed little over the years. While he painted in a realist style and continued to be interested in sunlight and the city—a continuation of the Impressionist and Ashcan traditions—his works remain unaffiliated with any one school. Indeed, when asked late in life what he was trying to accomplish, Hopper responded, "I'm after me." Accordingly, it is best to view Hopper's paintings in terms of the unique themes and subjects he chose to paint.

City Views

Hopper's city scenes explore the alienation and loneliness of urban existence. During his lifetime, the artist witnessed the rapid growth and expansion of New York City. When he first arrived in New York in the early 1900s, the city still possessed some remnants of small-town life. By the 1930s, however, this small-town atmosphere was waning.

Hopper's interest in New York as a subject for his paintings seemed to be centered around the effects of the city's growth on both its architecture and population. Instead of focusing on the excitement of the city,

Office at Night
detail; 1940; oil on canvas;
Walker Art Center, Minneapolis.
The voluptuous secretary invitingly glances out at the viewer. Her subordinate position in this office is cleverly emphasized by the placement and cropping of her desk and typewriter. Small to begin with, it is further diminished in our view by the fact that we see only a portion of it. Compared to the ample desk of the man's, it appears cramped and uncomfortable.

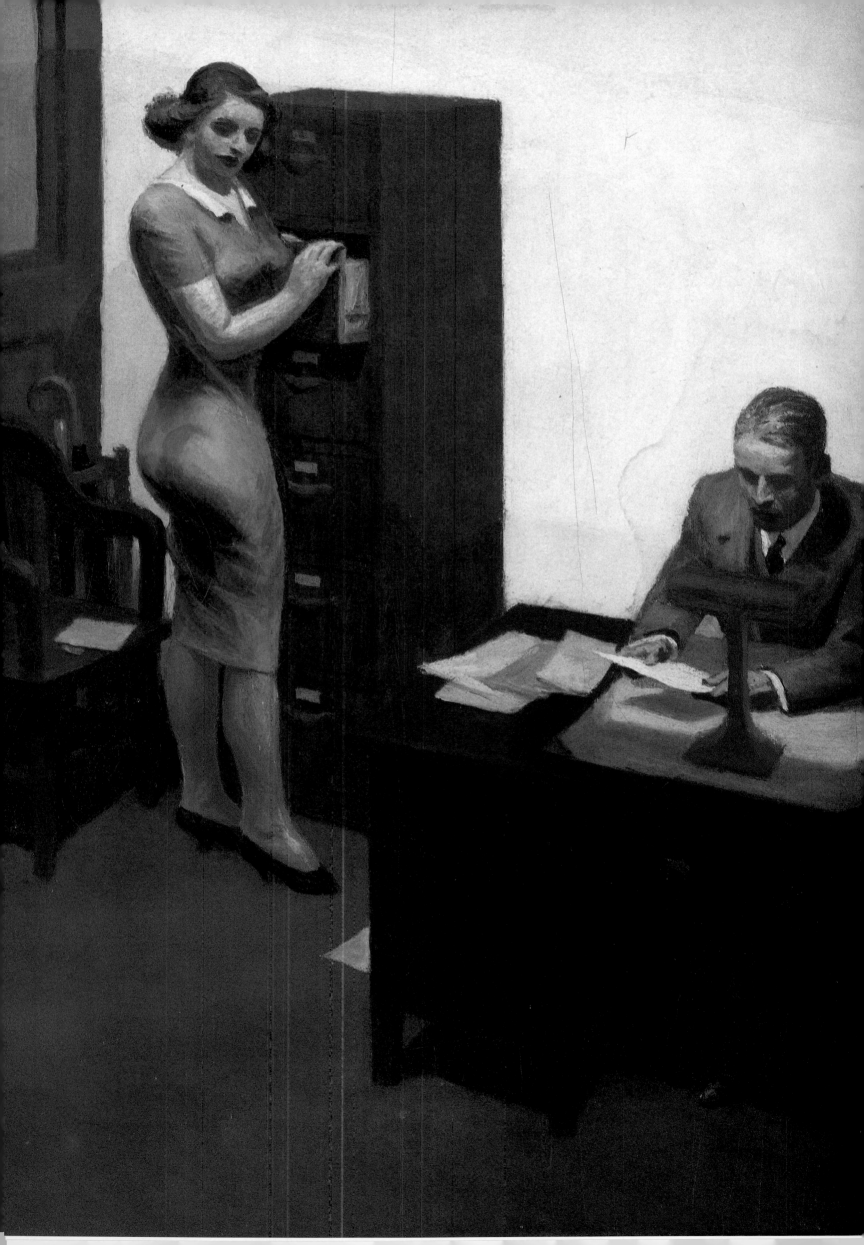

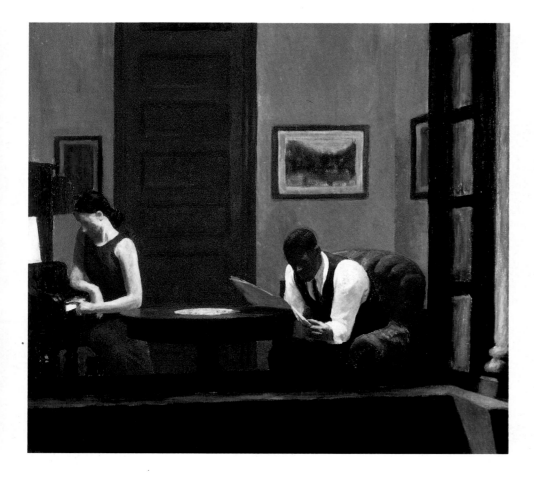

Room in New York

1932, oil on canvas; 29 x 36 in. (74 x 91 cm).
Sheldon Memorial Art Gallery and Sculpture Garden, University of Nebraska, Lincoln.
The inspiration for *Room in New York* came from the lighted interiors Hopper
observed while walking at night through his Washington Square neighborhood.
The work is a synthesis of the many rooms he had viewed over an extended
period of time. Hopper's intentional blurring of the facial features of the
couple is a reminder to his audience that the role of the voyeur gives only
a glimpse, not an in-depth understanding, of the lives of these individuals.

New York Movie

detail; 1939; oil on canvas; The Museum of Modern Art, New York.
Hopper transforms the dark interior of a movie theater into a study of light and
makes use of many sources and intensities of illumination throughout the painting.
The area around the usherette is the most defined, and the brightness from the
wall fixture highlights the gold of her hair and delineates the contours of her body.
Given such prominence within the composition, her relative status may be inferred.

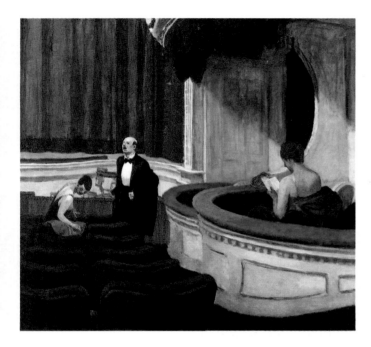

Two on the Aisle

1927, oil on canvas; 40 1/4 x 48 1/4 in. (102 x 123 cm.)
Toledo Museum of Art, Ohio.

During the 1920s and 1930s, the Hoppers frequently
attended the theater. This period corresponds to the
emergence of such well-known playwrights as Eugene O'Neil,
Maxwell Anderson, and Elmer Rice. In *Two on the Aisle*,
Hopper presents a couple finding their seats prior to the
performance. The lack of communication between the two
is evident as the man looks away from his companion towards
the rest of the theater. The woman, stylishly dressed, places
her coat against her chair and looks down. To the right, in
box, a solitary woman reads her program before the show.

First Row Orchestra

1951, oil on canvas; 31 x 40 in. (79 x 102 cm).
Hirshhorn Museum and Sculpture Garden,
Smithsonian Institution, Washington, D.C.

The Hoppers were avid fans of the theater throughout their
lives. When he used the theater as subject matter for his paint-
ings, Hopper chose to focus on the time before a performance
when the audience begins to assemble. The well-dressed couple
in *First Row Orchestra* represents the types of people he enjoyed
observing. Perhaps their quiet solitude and lack of interaction
appealed to Hopper, who was himself, primarily a loner.

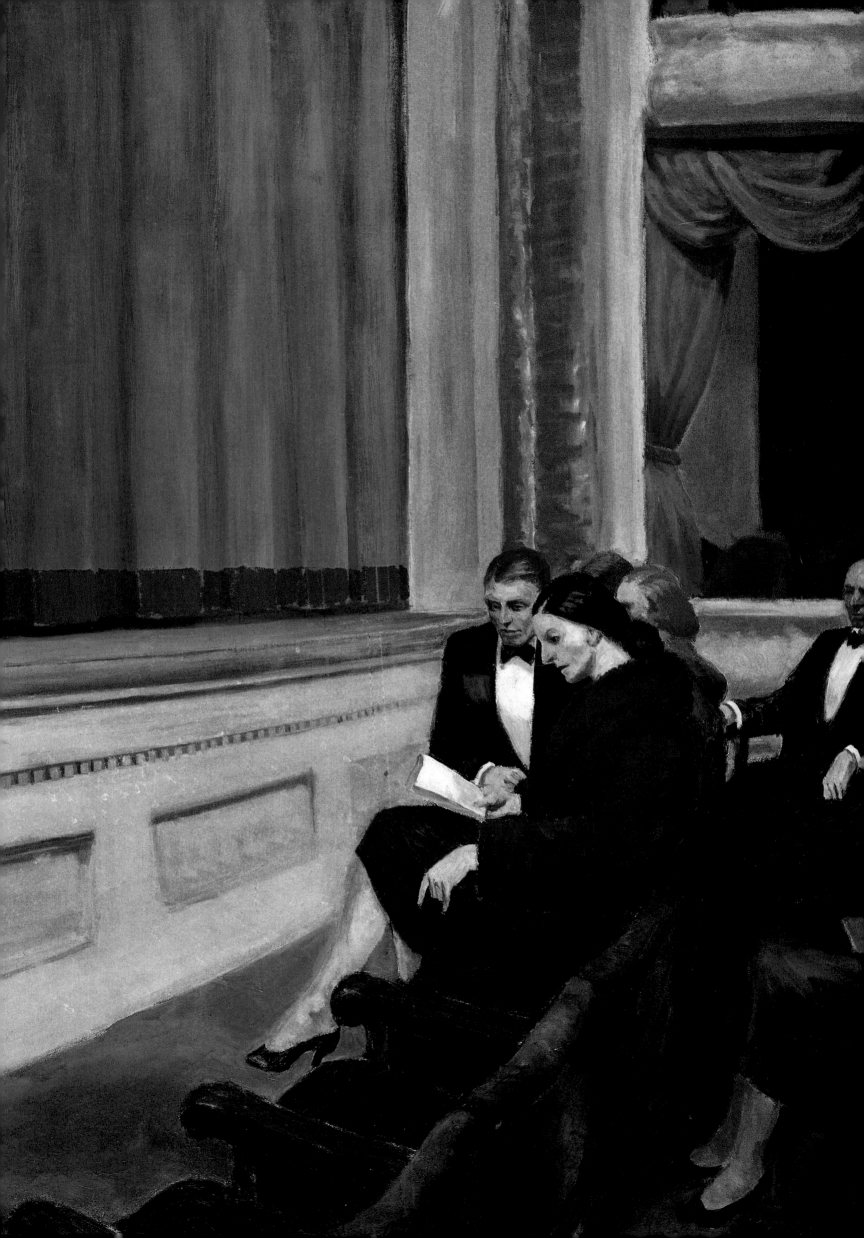

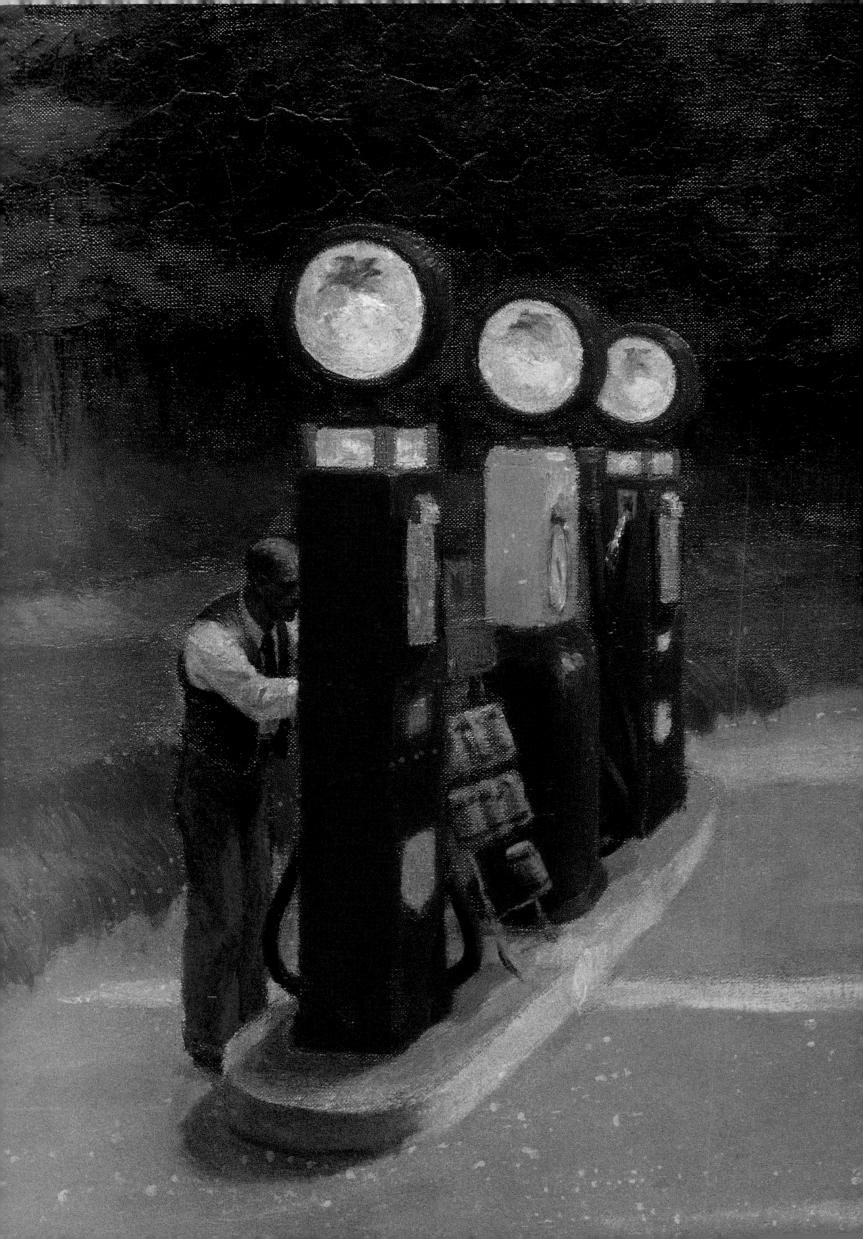

NEW MODES OF TRANSPORTATION: AUTOMOBILES AND TRAINS

*I*n the late 1920s, the American travel industry boomed. The most popular modes of transportation during this period were trains and automobiles. According to Hobbs, car registrations in America nearly tripled in the decade of the twenties, reflecting the ownership of over thirty-one million cars and four and a half million trucks in the United States.

The automobile, the newest mode of transportation, would considerably change the face American life. Roads, highways, gas stations, and motels all had to be built to service the needs of the ever-increasing number of drivers. Furthermore, cars and trains granted people greater freedom to travel and explore the country. Yet at the same time, as Hobbs explained, their view of the landscape became limited by their mode of travel. People's perceptions of the American countryside were increasingly restricted to what they saw from car and train windows—images of progress such as roads, signs, gas stations, and railroad tracks.

In 1927, the Hoppers joined the increasing number of American car owners. They purchased a Dodge. With the acquisition of their new auto, the Hoppers' proclivity for taking trips grew. Throughout the thirties and forties, whenever Hopper would get restless, he and Jo

would get in their car or on a train. In addition to traveling throughout New England, the couple visited Mexico and the southern and western parts of the United States.

With the growth of the travel industry, Hopper was exposed to a whole new area of subject matter. His art from the late twenties onward reflects his increasing interest in this phenomenon. It is remarkable how many

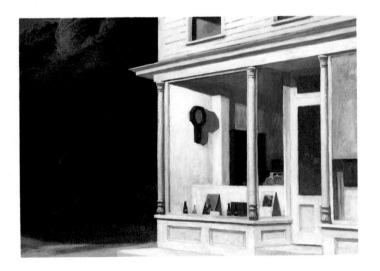

Gas
detail; 1940; oil on canvas;
The Museum of Modern Art, New York.
Hopper sought to create the perfect gas pump for this composition. The one in this work is therefore a composite of many pumps in different filling stations he came across during his travels. At the time this work was created Hopper took a benign view of the extension of modern life into the rural landscape. However, later on he changed his attitude as he saw the full effects of industrial society upon the natural world.

Seven A.M.
1948, oil on canvas; 30 x 40 in. (76 x 102 cm).
Collection of Whitney Museum of American Art, New York.
The rural counterpart to *Early Sunday Morning*, this work portrays Hopper's interest in small businesses. The varied objects in the shop window might suggest a curio shop, but the true nature of its business is quite elusive. Hopper places the scene in the early morning hours when the streets are still deserted. The homey, familiar atmosphere of the shop stands in contrast to the dark overgrown woods behind it.

out the window. Yet for the final version, he instead chose to have her read, an act which Levin suggests adds to the introspective nature of the composition.

Chair Car, painted in 1965, explores the isolation and lack of interaction between four passengers inside a sunny train car. Hopper's use of sunlight in this work serves as a barrier to further separate these individuals from one another. The woman in red will never engage the attention of the reading woman, nor of any other passenger in the car.

Automobiles

America, as viewed from Hopper's automobile, was changing rapidly. His paintings of gas stations and highways, unusual subjects in art history, seem to reflect the artist's own internal conflict with America's progress. Hopper's fascination with filling stations led him to paint several works on this subject. Apparently, he studied many gas pumps before creating those in *Gas* (1940), which depicts a seemingly brand-new Mobil station. The station, with its artificial lights and pristine cleanliness, appears to be an oasis of comfort for the weary traveler. This sense of hospitality is further evoked by Hopper's portrayal of nature as an overgrown forest, made all the more menacing by the approach of nightfall. Nonetheless, a feeling of loneliness pervades the work, as the solitary attendant waits for his next customer.

The El Station

1908, oil on canvas;
20 x 29 in. (51 x 74 cm).
Collection of Whitney Museum
of American Art, New York.
Hopper painted this work shortly after returning from his first European trip. New York's elevated train held a particular fascination for him, and many of his mature works, such as *Office at Night*, were inspired by the brief glimpses into rooms and offices he had while riding these trains during the late-night hours.

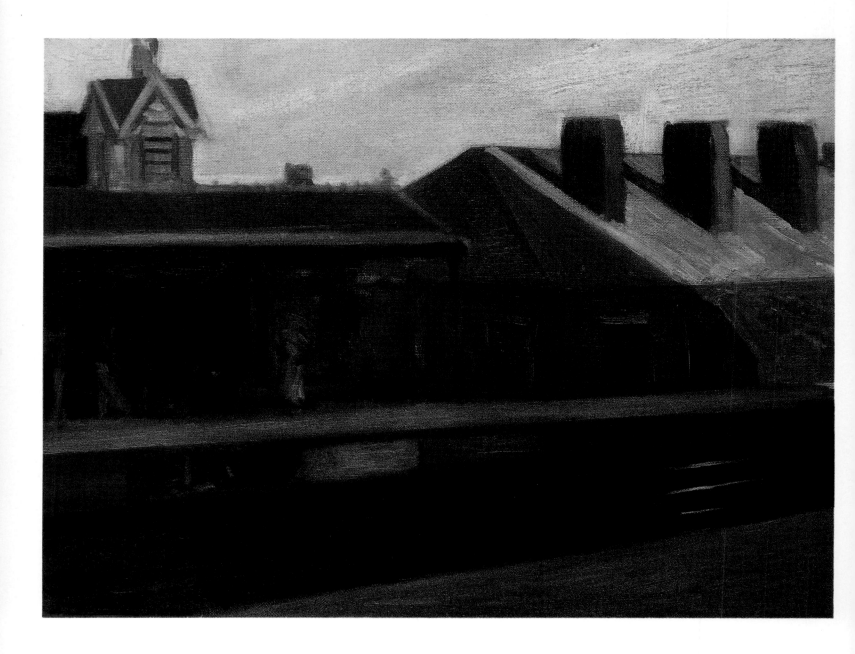

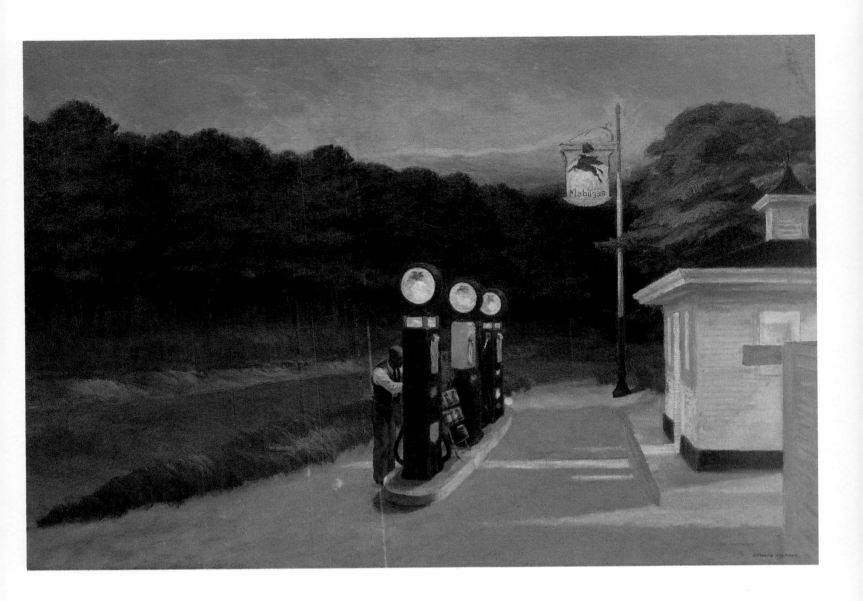

The roads Hopper passed while driving his automobile are forever recorded in works such as *Route 6, Eastham* (1941) and *Solitude* (1944). In these paintings, the artist captured the vast emptiness of endless highways and roads and the invasion of progress into the remote rural countryside.

The prospect of a night's rest after a long day of driving is the subject of Hopper's *Rooms for Tourists* (1945), evidently based on an actual boardinghouse in Provincetown, Massachusetts. Hopper's preliminary drawings for this work were executed while seated in his car. His decision to do this was, as Hobbs explains, intentional; the artist was determined to take the viewpoint of the tourist who, having arrived at a boardinghouse by car, now wonders if the lodgings will be suitable.

Hopper's intimate portrait *Jo in Wyoming* (1946) further evidences his use of views from his automobile as a context for his subject matter. This work reveals the manner in which Hopper may have arrived at his perspectives of roads and gas stations. The painting

Gas
1940, oil on canvas; 26 1/4 x 40 1/4 in. (67 x 102 cm).
The Museum of Modern Art, New York.
The automobile radically changed rural America during the decade of the 1920s. Highways, gas stations, and motels were built across the country to serve the needs of the automobile and those who traveled in it. In *Gas* Hopper portrays this invasion of modernization into the rural countryside. The pristine newness of the Mobil gas station contrasts with the wilderness in the distance.

Following page:
Pennsylvania Coal Town
1947, oil on canvas; 28 x 40 in. (71 x 102 cm).
The Butler Institute of American Art, Youngstown, Ohio.
A solitary figure raking leaves is the subject of this painting. The features of the man look quite similar to the man in *Sunday*, a work painted twenty-one years earlier. The seeming re-use of characters from earlier works fits into Hopper's and Jo's game of naming characters in his paintings and creating stories for their lives.

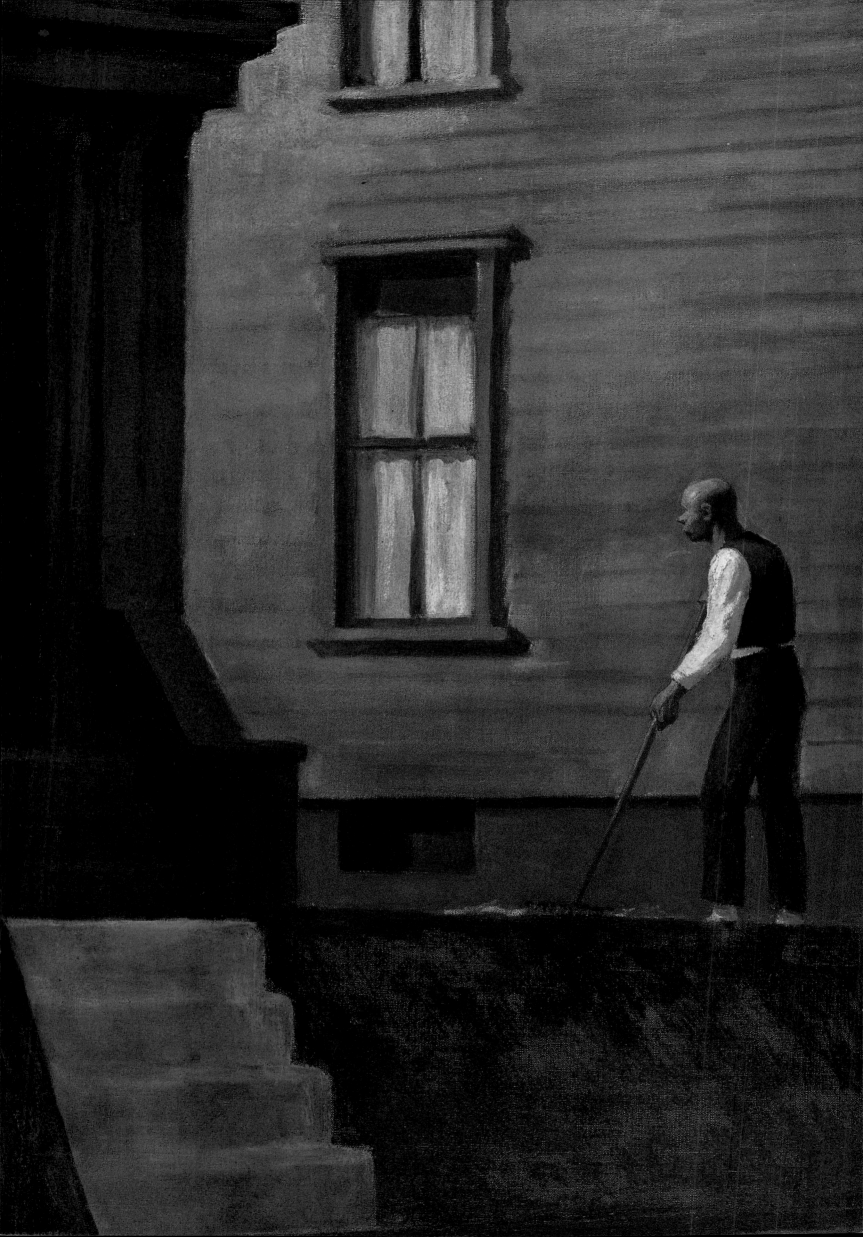

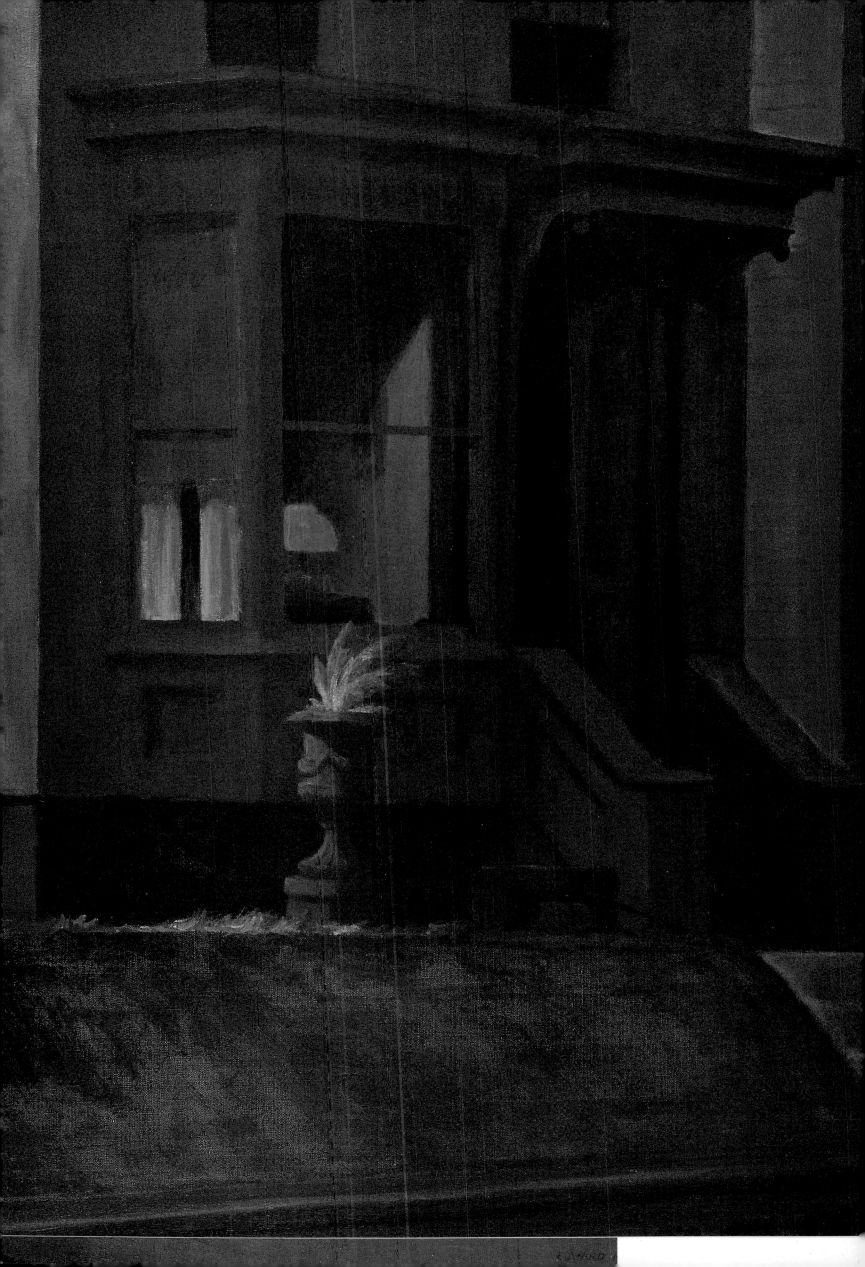

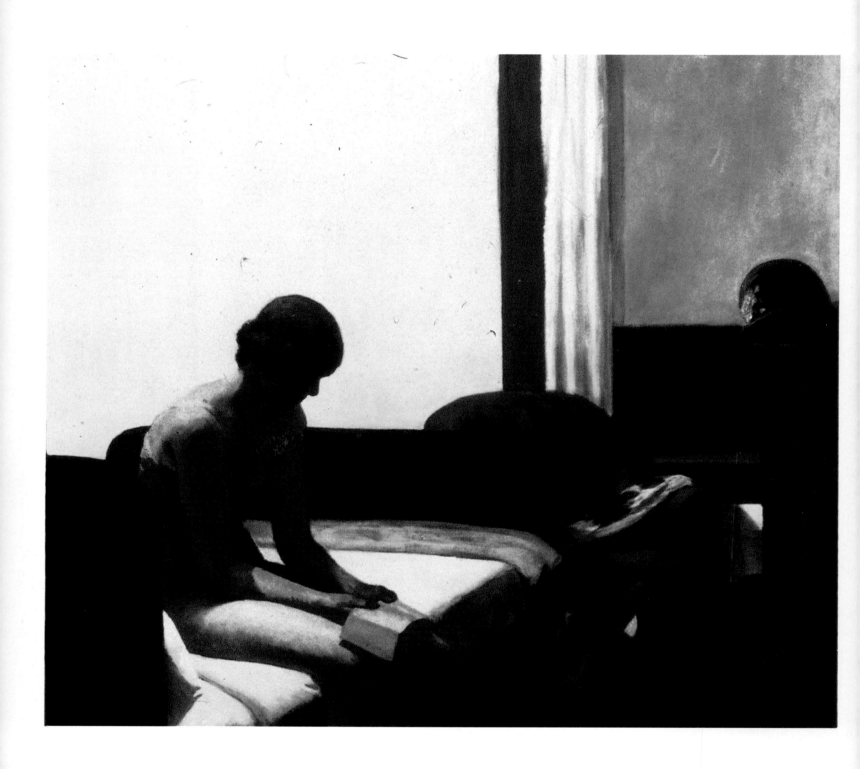

Hotel Room

1931, oil on canvas; 60 x 65 in. (152 x 165 cm).
Museo Thyssen-Bornemisza, Madrid, 1995.

Hopper was fascinated with the psychology of travelers. While he
never returned to Europe after 1910, Hopper and Jo traveled extensively
in Mexico, New England, the South, and the far West. As his paintings
of hotel rooms suggest, Hopper recognized the universal loneliness
of the traveler. In fact, here the isolation of the woman is all the
more poignant because of the transient nature of the hotel room. The
drama of this painting lies in the letter the young woman is holding,
the content of which Hopper leaves to the imagination of the viewer.

Western Motel

detail; 1957; oil on canvas;
Yale University Art Gallery, New Haven

As the picture postcard effect of the mountain scenery
outside the window suggests, this woman only sees the
landscape through the eyes of a tourist. Her situation is
enigmatic. She appears to be waiting, but though the
packed bags and the car outside are clues, it is unclear
whether she is about to depart or has just arrived. She
stares straight forward, making eye contact with the viewer,
or perhaps with the person for whom she has been waiting.

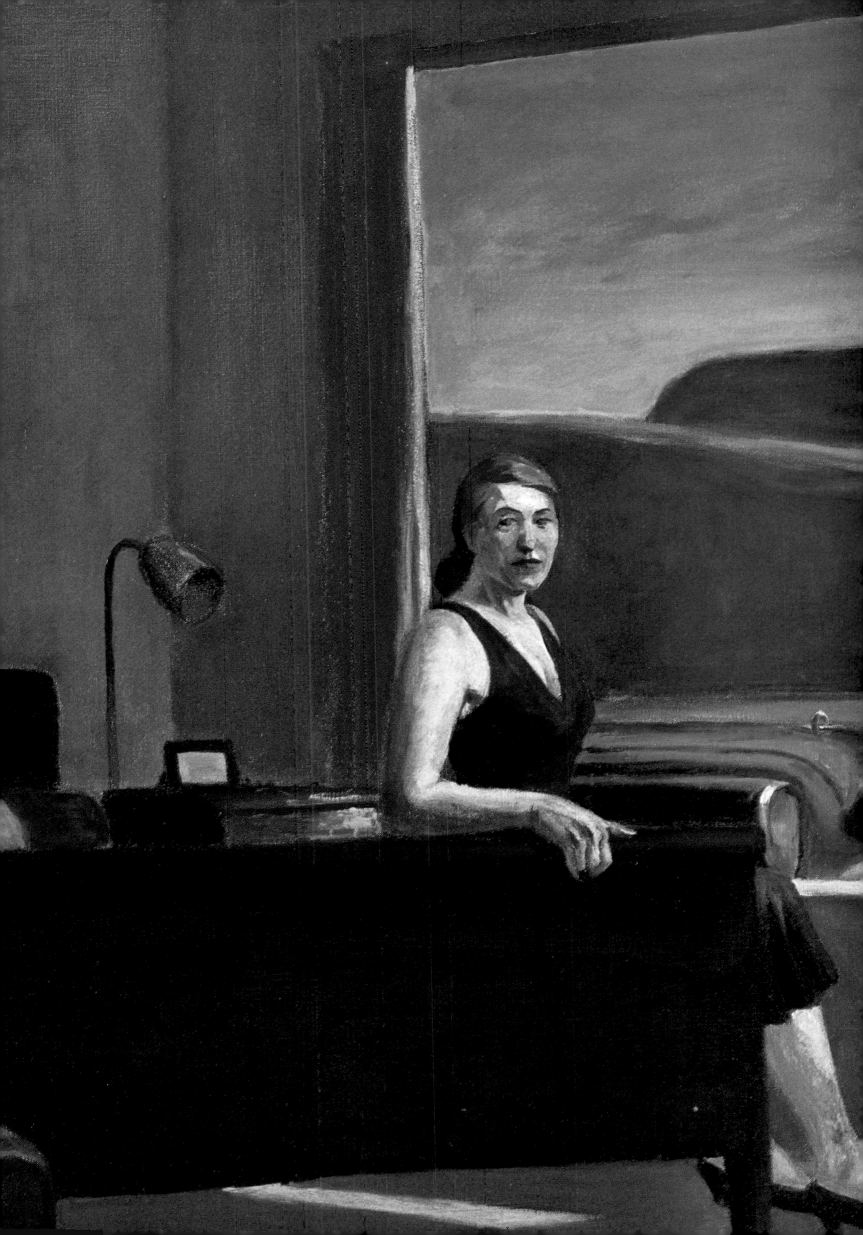

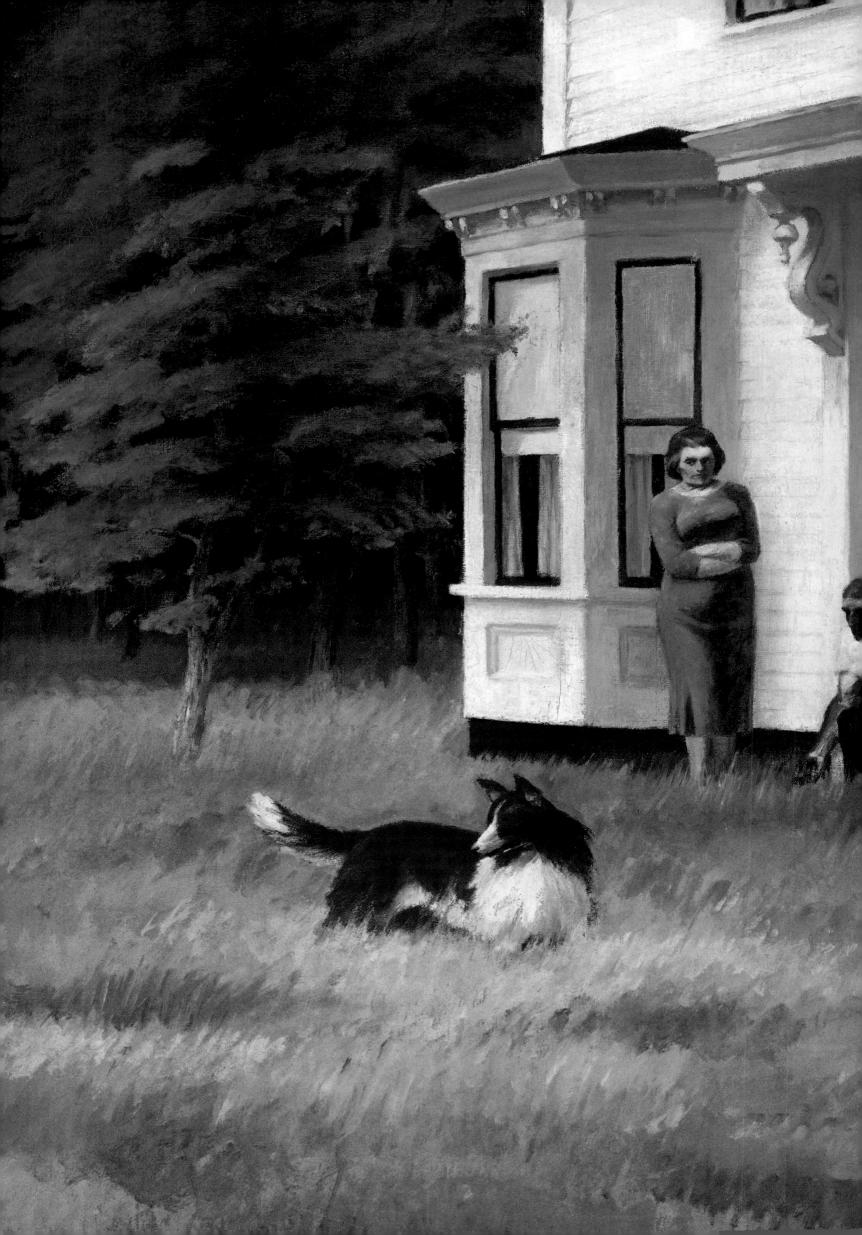

LATE WORKS: SUNLIGHT AND A FINAL BOW

*T*he paintings Hopper executed during the last fifteen years of his life emphasize his fascination with light, particularly sunlight. This was not a new interest for the artist. It was a subject that had concerned him since his student days in Paris in the early 1900s. Describing this lifelong attraction, Hopper once said, "What I wanted to do was paint sunlight on the side of a house." In his late works, he tended to let sunlight dominate his canvases. His works of this period, however, differ from those of the Impressionists in that Hopper never allowed his rendering of light to diffuse the physical reality of the objects in his compositions.

The reemergence of sunlight in Hopper's late works may be due in part to his advancing age. In the 1950s the Hoppers' interest in grand adventure waned, and they spent more time at their home on Cape Cod. The

Cape Cod Evening

1939, oil on canvas; 30 x 40 in. (77 x 102 cm).
National Gallery of Art, John Hay Whitney Collection,
©1995 Board of Trustees, Washington, D.C.
The impetus for this scene comes from the call of a whippoorwill or some other sound that has interrupted the stillness of the quiet evening. The collie turns from his owners to determine the origin of the sound. In Hopper's ledger book, the artist described the woman in the painting as a Finnish type, common to the Cape, and the man as a dark-haired Yankee. Hopper did not intend the work to be an exact transcription of a place, but rather a series of many impressions of Cape Cod gathered over a period of time.

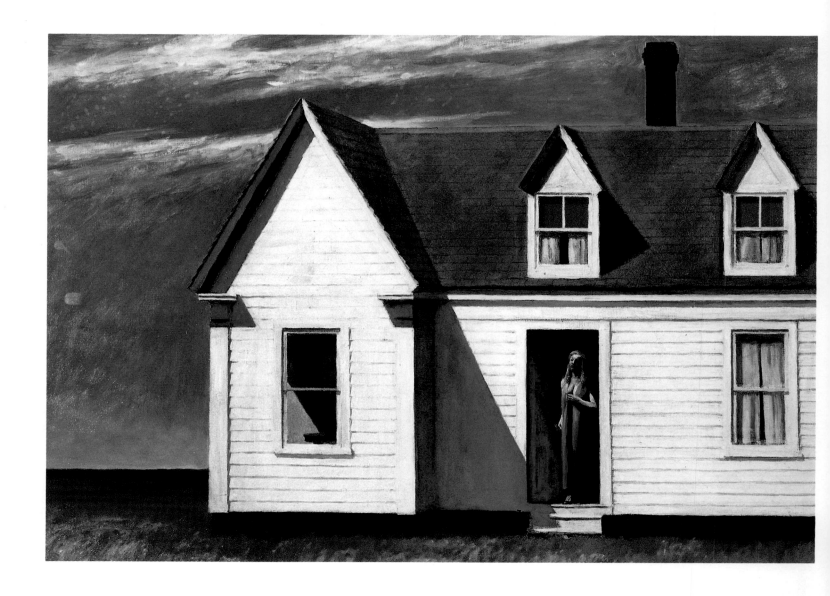

High Noon

1949, oil on canvas;
28 x 40 in (71 x 102 cm).
The Dayton Art Institute,
Gift of Mr. and Mrs. Anthony
Haswell, 1971.7, Dayton, Ohio.
The provocative woman in this
work appears to be basking in the
sun by her open doorway. In the
1950's Hopper developed an interest
in light, in particular the sunlight
of Cape Cod. He was so determined
to capture the right intensity of
brightness in *High Noon* that he
built a cardboard model of the
house in the painting, and placed
it outdoors. Through observation
of this model, Hopper was assured
that he could capture the correct
amount of sunlight for his work.

surprisingly similar in tone to that of the surrealist work of the Belgian artist René
Magritte.

Hopper's subject matter of this period, however, was by no means limited to views from
his home. People experiencing the sun both indoors and outdoors was a predominant
theme of Hopper's late works. He was particularly interested in painting people sitting or
standing inside rooms filled with sunlight. In many of these pieces, such as *Cape Cod
Morning* (1950), the figures seem to be basking in a ray of sunlight streaming through a
window.

In High Noon (1949), a blond woman wearing a bathrobe stands by her open door bask-
ing in the radiant Cape Cod sunshine, which seems to assume a role far greater than its
physical reality. The sunlight appears to be linked to the woman's awakening sexuality.
Indeed, it highlights her ample breasts which can be glimpsed through the parted robe.
One could view this work as Hopper's modern Danaë. In representations of the mytho-
logical story of Zeus and Danaë, of which Hopper was well aware, Zeus appears as a
shower of radiant gold to rob the young nymph's virginity. Furthermore, the composi-
tional similarities between the rural scene in *High Noon* and the urban scene in
Summertime (1943) lead one to believe that the two works may have been pendants for
one another. Both works portray a sexually provocative younger woman stepping out into
a glorious summer day from a house with a shadowy interior.

Hopper also frequently painted pictures of people sunbathing, by now a popular pastime
on the Cape. In *Second Story Sunlight*, he depicted two generations of women, perhaps from

the same family, sunning themselves. Hopper referred to the teenage girl as "Toots," and as her name suggests, she is, in contrast to the older woman, bursting with sexuality and life. Sunbathing is the topic of *People in the Sun* (1960) as well. With their chairs facing into the sun, the five figures appear to be merely sunning themselves, and yet at the same time their experience seems more akin to a spiritual awakening than a leisure activity.

Hopper's use of sunlight in his late works as a metaphor for transcendental revelation is best exemplified by *Excursion into Philosophy* (1959). In this painting, a man seated on a bed with an open book beside him contemplates a spot of sunlight on the floor. A woman lies on the bed next to the man—her back turned away from the viewer. In Hopper's ledger books, Jo interpreted the composition as follows: "The open book is Plato, reread

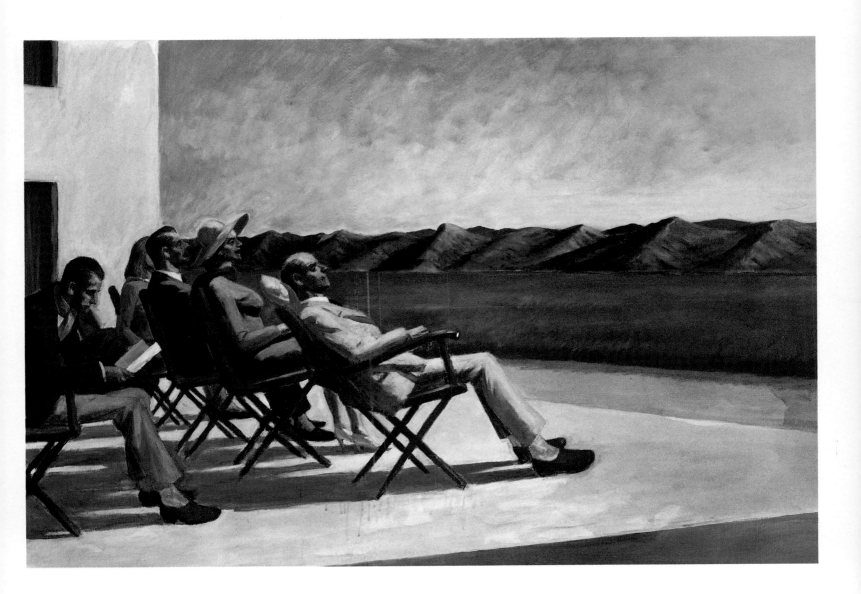

People in the Sun

1960, oil on canvas; 40 x 60 in. (102 x 152 cm).
National Museum of American Art, Smithsonian, Washington D. C.
The nationally popular pastime of sunbathing must have appealed to Hopper because it allowed him to explore two elements important to his art: the play of light and the portrayal of people. In this work he presents a crowd of people basking in the sun. As is to be expected in Hopper's work, none of these individuals interact with one another. While particpating in the same activity, their leisure time is not to be shared.

Following page:
Cape Cod Afternoon
1936, oil on canvas; 34 3/16 x 50 1/16 in. (87 x 127 cm).
The Carnegie Museum of Art, Pittsburgh.
Hopper's interest in painting specific times of day resulted from his enthusiasm for the French Impressionists. In this work, Hopper combines one of his favorite subjects, Cape Cod architecture, with the interplay of sunlight. He managed to capture the beauty of a summer afternoon in this rendering of simple structures, such as this farmhouse which is typical of those commonly found on the Cape.

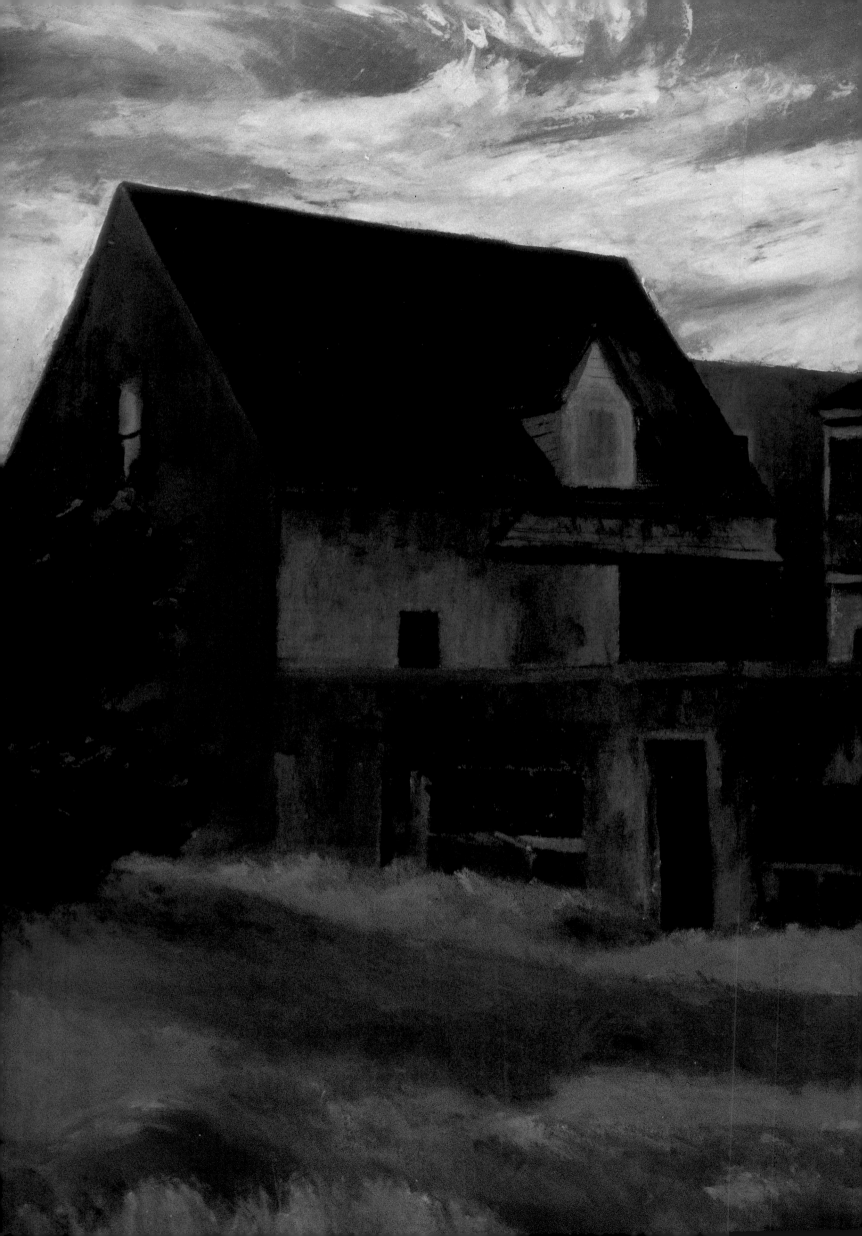

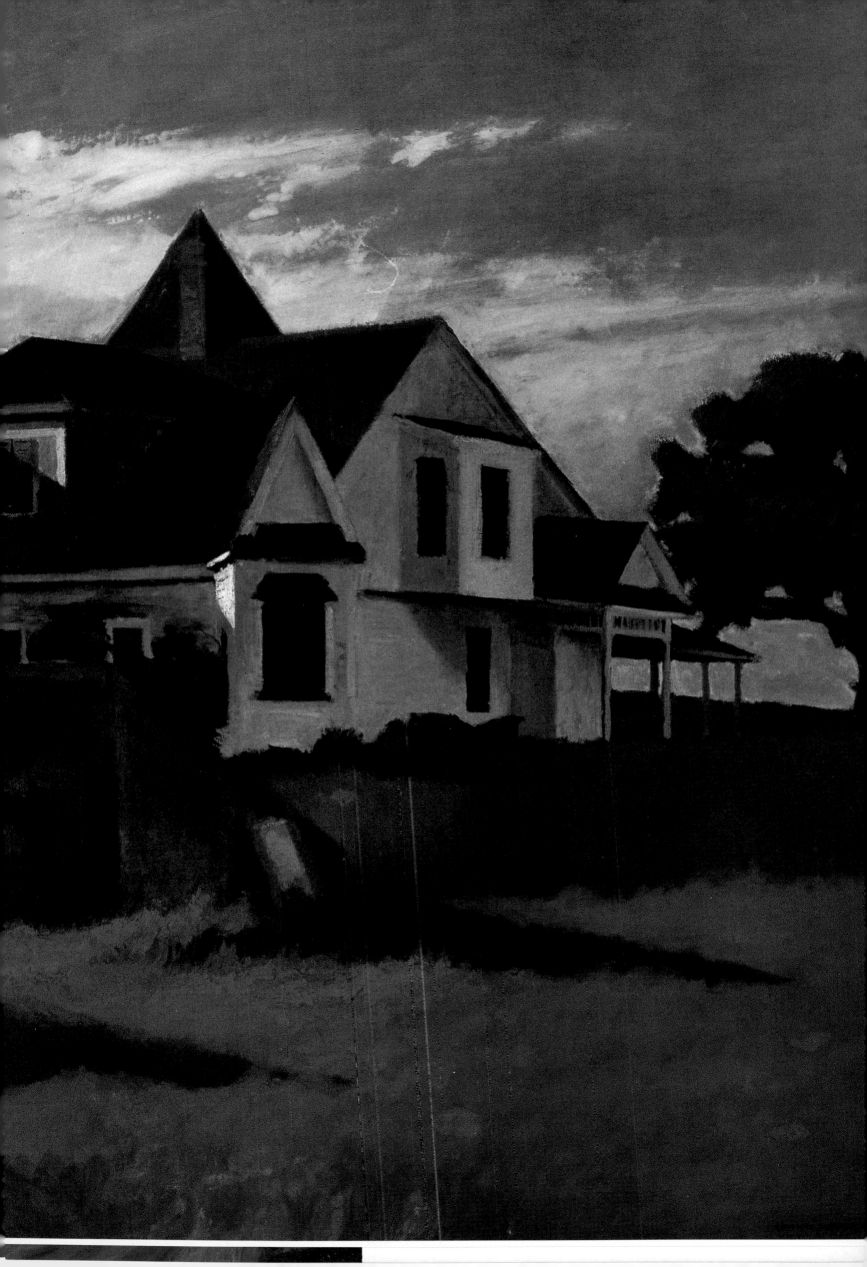

INDEX